D0163999

Creative Character Design

Second Edition

I would like to dedicate this book to my wife for always being my rock, to my children for being the motivation to do everything I do, and to my parents for being true teachers. Thank you all. I love you all very much.

Contents

Creative Character Design

Second Edition

By
Bryan Tillman

CRC Press
Taylor & Francis Group
Boca Raton London New York

CRC Press is an imprint of the
Taylor & Francis Group, an **informa** business

A FOCAL PRESS BOOK

CRC Press
Taylor & Francis Group
6000 Broken Sound Parkway NW, Suite 300
Boca Raton, FL 33487-2742

© 2019 by Taylor & Francis Group, LLC
CRC Press is an imprint of Taylor & Francis Group, an Informa business

No claim to original U.S. Government works

Printed on acid-free paper
International Standard Book Number-13: 978-0-8153-6543-3 (hardback)
International Standard Book Number-13: 978-0-8153-6539-6 (paperback)

This book contains information obtained from authentic and highly regarded sources. While all reasonable efforts have been made to publish reliable data and information, neither the author[s] nor the publisher can accept any legal responsibility or liability for any errors or omissions that may be made. The publishers wish to make clear that any views or opinions expressed in this book by individual editors, authors or contributors are personal to them and do not necessarily reflect the views/opinions of the publishers. The information or guidance contained in this book is intended for use by medical, scientific or health-care professionals and is provided strictly as a supplement to the medical or other professional's own judgement, their knowledge of the patient's medical history, relevant manufacturer's instructions and the appropriate best practice guidelines. Because of the rapid advances in medical science, any information or advice on dosages, procedures or diagnoses should be independently verified. The reader is strongly urged to consult the relevant national drug formulary and the drug companies' and device or material manufacturers' printed instructions, and their websites, before administering or utilizing any of the drugs, devices or materials mentioned in this book. This book does not indicate whether a particular treatment is appropriate or suitable for a particular individual. Ultimately it is the sole responsibility of the medical professional to make his or her own professional judgements, so as to advise and treat patients appropriately. The authors and publishers have also attempted to trace the copyright holders of all material reproduced in this publication and apologize to copyright holders if permission to publish in this form has not been obtained. If any copyright material has not been acknowledged please write and let us know so we may rectify in any future reprint.

Except as permitted under U.S. Copyright Law, no part of this book may be reprinted, reproduced, transmitted, or utilized in any form by any electronic, mechanical, or other means, now known or hereafter invented, including photocopying, microfilming, and recording, or in any information storage or retrieval system, without written permission from the publishers.

For permission to photocopy or use material electronically from this work, please access www.copyright.com (http://www.copyright.com/) or contact the Copyright Clearance Center, Inc. (CCC), 222 Rosewood Drive, Danvers, MA 01923, 978-750-8400. CCC is a not-for-profit organization that provides licenses and registration for a variety of users. For organizations that have been granted a photocopy license by the CCC, a separate system of payment has been arranged.

Trademark Notice: Product or corporate names may be trademarks or registered trademarks, and are used only for identification and explanation without intent to infringe.

Library of Congress Cataloging-in-Publication Data

Names: Tillman, Bryan, author.
Title: Creative character design / Bryan Tillman.
Description: 2nd edition.
Boca Raton : Taylor & Francis, a CRC title, part
of the Taylor & Francis imprint, a member of the Taylor & Francis Group,
the academic division of T&F Informa, plc, 2019.
Identifiers: LCCN 2018045178 ISBN 9780815365396 (paperback : acid-free paper)
ISBN 9780815365433 (hardback : acid-free paper)
Subjects: LCSH: Characters and characteristics in art. | Cartoon characters.
| Video game characters. | Graphic arts--Technique. | Animation (Cinematography) | Computer animation.
Classification: LCC NC825.C43 T55 2019 | DDC 741.58--dc23
LC record available at https://lccn.loc.gov/2018045178

Visit the Taylor & Francis Web site at
http://www.taylorandfrancis.com

and the CRC Press Web site at
http://www.crcpress.com

Foreword

CHARACTER BIO:

Name:
Bryan "Kaiser" Tillman

Age:
30, as of this writing

Height:
6 feet, 2 inches or 6 feet, 8 inches (including Afro)

Weight:
220 pounds

Build:
Fit, mesomorph

Nationality:
German-American

Birthplace:
Fort Hood, Texas

Alignment:
Lawful good (with a touch of chaos)

Weapons:
His Afro, a pencil, an ink pen, and anything ninja

Favorite Saying:
"You FAIL!"

Biography

How can I write this without making it sound like Bryan paid me to write it?

He didn't, really; he just asked. My answer? "Absolutely!"

Bryan lives his life with passion. He deeply loves his wife, really loves his kids, and sure as hell loves his craft. In the time that I have known him, I have watched Bryan put all of himself into everything he does. Outside of being a great husband and father and fulfilling the requirements of his day job, Bryan has attended every major convention I know of; designed, developed, and released an excellent fantasy card RPG; and managed to get his own convention up and running in the Washington, DC, area. He is like some kind of mad comics superhero.

The passion that Bryan has for his craft, Sequential Art, is second to none. It is that passion that is the origin of this book you hold in your hands. You see for years we have been squabbling amongst ourselves about the hollow materials that have been hitting the shelves or being released in theatres, but Bryan has been telling the masses. Why? Because he is passionate about it, so passionate that he wants you to learn how to do it right. (Okay, so I know that is improper grammar, but I think you get the point.) This book is the pathway

to success in the media and entertainment industries. When you look at the stories you like today, the movies you love, and the games you like to play, for the most part, the reasons you like them are unfolded here. Take this book. Read it. Listen to it. Apply it with the passion that Bryan has, and someday, when you are at the top of the mountain, remember the passion that Bryan "Kaiser" Tillman had, the passion that helped you build your foundation to success.

Alexander Buffalo

Credits

The art in this book was provided by the members of Kaiser Studio

Productions. http://www.kaiserstudio.net.

Kaiser Studio Productions consists of:

Bryan "Kaiser" Tillman
Crystal Tillman
Elvin Hernandez
Alex Buffalo
Enrique Rivera
Jerald Lewis
Kenneth Hill II
Kevin Martin
Danny Araya
Jonathan Stuart

Also, guest illustrations by:

Chris Lie
www.caravanstudio.com

Sam Ellis
http://manofmisle.blogspot.com

What Makes for Good Character Design?

Hello everyone and welcome to *Creative Character Design*. Before we get started, there are two things that you need to know about this book.

ONE: This is and forever will be an introductory book to character design. I want to make sure that you know that going in so that you won't be disappointed by the end of this book. There are always nuggets of information that can be gleaned from any book, so no matter what skill level you are at with character design, there will be some information in this book that can help you with your future character design needs.

TWO: This is not a how-to-draw book. *Creative Character Design* is a book about the theory of character design and what elements and aspects need to be thought about before and during the drawing process. I try and pull back the curtain a little bit to give beginning designers a look at what makes some characters great and some characters meh.

Now that that is out of the way, and if you are still with me, why don't we jump right in to answering some questions that you might have.

At this point you might be thinking to yourself:

O.K., I bought this book, so hurry up and tell me what makes for a good character design.

Well, I hate to have to tell you, but you are just going to have to read the whole book to find *that* out. Sorry. One thing I have learned in my years as a teacher is that the quick answer won't teach you anything in the long run. It is like cramming for a test. You know everything you need to know for the test, but then you forget everything the very next day. So, I'm not going to do you that disservice, but what I will do if you are in such a hurry is give you a brief overview of what this book is all about. So, sit back, relax, and enjoy this fast-paced, high-octane summary of creative character design. Are you all strapped in and have your helmet on? Great! Here we go!

When most people think about characters or character design, there are a few things that jump into their mind. From my experience, what most people think about is either the characters that captured their imagination as a child or one of the most recent characters that they have seen, played, or read. The main reason why we as humans will gravitate to a character that we remember from our childhood or from a more recent experience is because we either were on some level able to relate to the character or wanted to see ourselves in one of those character roles. Speaking of character roles, there are a few that most people instantly think of when talking about characters. Most people will say:

There needs to be a hero.

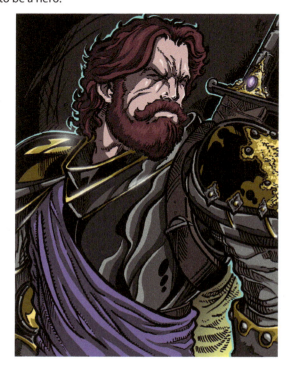

There needs to be a bad guy.

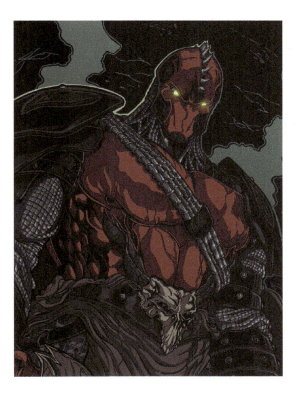

There needs to be a beautiful woman.

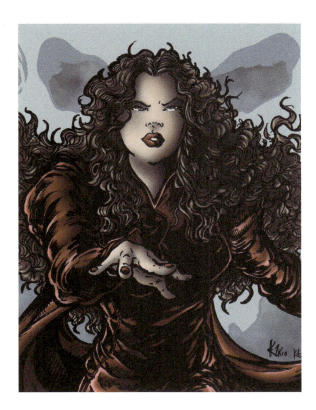

This is pretty much standard, but I know some of you are now yelling at the book:

"Hey, my hero is a ninja!"

or **"My bad guy is a situation, not an actual person!"**

or **"My villain is a woman!"**

Yes, you are allowed to have these variations; it is actually encouraged to think outside of the norm and create characters that are different. By adding variations, the world of character design will never grow stagnant.

PRO TIP!

Stay modern, stay fresh, constantly be paying attention to what is going on around you. Character designs are very "in the moment"; stale designs equal no work.

—Bun Leung

With that said, it has been my experience that, when given the task of creating characters, the first three are the most common. As you continue reading the book, we will get into variations of the initial thought process of character design. However, for the sake of this introduction, we are going to stick with these core principles.

The first step in good character design is these core principles, known as *archetypes*. Archetypes represent the personality and character traits that we as humans identify with. There are many different archetypes, but there are a common few that keep reoccurring in all types of stories. They are needed in order to propel a story forward, and it is the personal story of each character that makes for good character development.

Story is the second step to good character design. Even though it is the second thing mentioned, it is the most important. If you are willing to put in the time and effort to develop each character—their backstory and personality traits—before you start drawing, you will have a stronger and more well-rounded character design, which will in turn

strengthen the aesthetic of your character in the future. The thing that you as the character designer must remember is that the characters are *always* in service to the story—not now, nor will it ever be, the other way around.

I am sure that your blood is starting to boil, and you are asking:

"Wait a minute! I've created characters without a story before."

Yes, it is possible to draw a character without a story, and people do it all the time. The problem is, when you do that, and you want to keep the character, you always have to go back and create the story for that character. I don't know about you, but whenever I created the design of a character without writing his or her backstory first, the design of the character always changed once I wrote it. Has that ever happened to you? If you answered yes (which all of you should have), what you were subject to was:

The Character is *Always* in Service to the Story

The third step we are going to talk about is the idea of being *original*. When you are writing your backstory, it will be *impossible* to ignore the things around you. Whether you want to be or not, every day you are influenced by the things you see, hear, and do. That is why it is so hard to come up with an original idea. I'm not saying that it is impossible, but it is really, *really* hard to do. Have you ever heard this before?

"Oh, that story sounds great. It reminds me of the other story."

If that has happened to you, don't get discouraged. It's perfectly okay. The only thing you need to remember is that you bring some form of originality to the table.

What does he mean by that?

Well, you are just going to have to read the chapter on originality to find that one out.

Moving right along, the fourth step to good character design that we cover in this book is *shapes*. That's right—shapes. Shapes play a big role in character design. They visually can tell a lot about a character and their story. How is that possible, you ask? Well, every shape has a meaning behind it. If you are thinking in terms of a basic square, circle, or triangle, it might not make too much sense, but when you start tweaking these shapes, they tell a story. What do you think this character is all about?

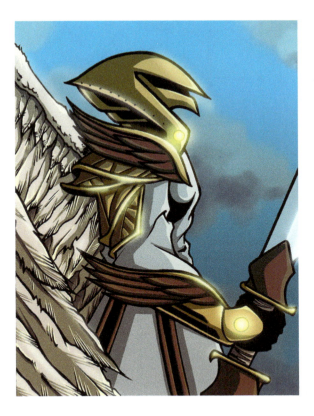

Did you notice you were coming up with a story based on the armor, the helmet, and the weapons? All those have distinctive shapes that were chosen to tell a story about this character visually. Shapes also give us the means to talk about silhouettes and functionality, which we will talk about in depth later in another chapter.

The fifth step—*reference*—is one of my favorites. The topic of using reference is what plagues my students the most. Here are some of the most common statements I hear when talking about reference:

> **"I already know how to draw a tree, so I don't need reference."**
> **"I couldn't find exactly what I was looking for, so I just made it up."**
> **"Isn't using reference cheating?"**

Here are my responses to the three statements above.

> **"Yeah, you do."**
> **"You have got to be kidding me."**
> **"Let's see. All of the pros use reference, so … *no*! Now stop being stupid!"**

I know the last statement might have been a bit harsh, but let me explain. It is one thing to use reference, and it is another thing to let the reference use you. *Don't copy your reference!* If you are going to do that, then you might as well just take a photograph and save yourself some time. Reference is very important to character designers and, well, artists in general.

You might think you know how to draw everything in the world, but trust me—you don't. Here is an example: ask somebody to draw a car and see what that person comes up with. Anyone can draw something that resembles a car, for example:

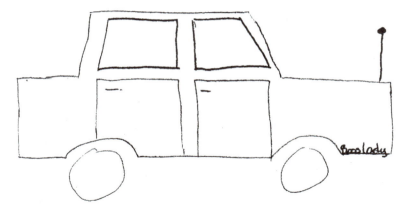

Now ask somebody to draw a Dodge Viper.

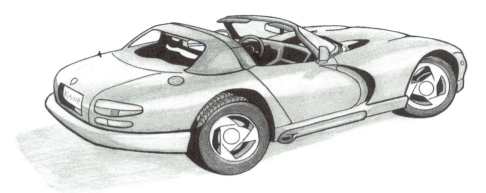

There are two ways the drawing will be accurate. One is that the artist is a Dodge Viper fanatic and eats, sleeps, and dreams Dodge Vipers, and the other is that the artist got the proper reference before creating the drawing.

From that we move on to the sixth step: *aesthetic*. This is the one that the majority of all character designers go after first. The aesthetic is the look of the character. Since we are mainly talking about a visual medium, this is a very important subject. The way a character looks determines whether the viewer likes, dislikes, connects with, sympathizes with, or anything else. There are many things to consider when thinking about aesthetic, for example:

What style should be used when creating this character?
What colors should be used?
What medium is this character going to be used for?
Who is the character's audience?

These are some of the questions that need to be answered before you get to the final piece. If any of these questions are answered after the final design is created, then I can guarantee you that changes will be made to your design. This is extremely important to the success of your character design, and we will cover it in full detail in a later chapter. (I know you want to look. Go ahead, I'll wait. Just make sure you come back.)

Welcome back! Okay, let's finish this up with a brief summary of the final step. The last subject deals with something I like to call the *WOW factor*. Every design needs to have this. Every designer wants this in his or her designs. What is the WOW factor, you ask? Well, I'm not going to tell you yet. You will have to read the entire book to fully understand it.

There is one thing, however, that I *will* tell you: Once you've read this book, you will have the knowledge to create eye-popping, jaw-dropping character designs. So, what are you waiting for? Times a ticking. Go on to the next chapter!

Why Archetypes Are Important

I should warn you that the next two chapters aren't going to have as much art as all the other chapters, but these two chapters are the most important in this entire book. So—and this is *very* important— *don't take these two chapters lightly! I just want to make sure you understand what I just said, so I am going to say it again. DON'T TAKE THESE TWO CHAPTERS LIGHTLY!*

As mentioned in Chapter 1, certain traits are evident in all characters. These traits, called archetypes, allow us to categorize them into specific groups. An archetype is considered to be the original mold or model of a person, trait, or behavior that we as humans wish to copy or emulate. It is the *ideal* example of a character. Archetypes encompass both the good and evil spectrums. Character designers can use this to their advantage both for a clear understanding of a character and to blur the understanding of a character. We will talk a bit more about that later.

A wide variety of archetypes can be found throughout history, from the works of Shakespeare all the way back to the teachings of Plato. You can spend some time in the library researching archetypes throughout history, but we are going to focus on a specific grouping of archetype. Today, the most prevalent archetypes used are set forth by the Swiss psychologist Carl Jung. Jung, a colleague of Sigmund Freud, studied the idea of the conscious and unconscious mind. He believed that multiple reoccurring innate ideas defined specific characters. It is these reoccurring ideas that we as humans grasp onto in order to define people we encounter in our everyday lives, as well as characters in fictional works. These basic archetypes exist in all literature. The Jungian archetypes are pretty self-evident, but once you become more familiar with the various archetypes and what they mean, they become much more recognizable and thus make character development easier as well. If you would like to look for another person that dives into the commonality of character archetypes throughout history and global mythology, then look no further than Joseph Campbell.

His work *The Hero with a Thousand Faces*, published in 1949, has been a cornerstone for many artists, authors, game designers and filmmakers. In the writings of *The Hero with a Thousand Faces*, Campbell outlines the hero's journey, which is a common theme of adventure and transformation that can be seen in pretty much all the mythology and stories.

PRO TIP!

The whole Joseph Campbell concept of the classic heroic figure against shadow characters still works perfectly.

—Elvin Hernandez

There are a plethora of archetypes and the meanings that were developed from them; however, we will focus only on those most commonly used in storytelling today:

> The hero
> The shadow
> The fool
> The anima/animus
> The mentor
> The trickster

When dealing with character design, always remember that the character exists as a result of the story. The story will dictate that you need a *hero*. The hero is defined as someone who is very brave, selfless, and willing to help others no matter what the cost.

Now that we have established the hero, we are going to need an enemy for that person to interact with in the story. We are going to need to establish the *shadow* character. The shadow character is the one who is connected the most with our instinctual animal past. He or she is perceived as ruthless, mysterious, disagreeable, and evil.

Now that we have a good guy and a bad guy (or gal), we should be able to tell a great story, right? Well, just because you have the two main characters, it doesn't mean that your story is going to be great. You might be able to tell a compelling story with only two people, but that rarely happens. With that in mind, you are going to need a cast of supporting characters to help push the main characters through the story. This leads us to our next character: the *fool*.

The fool character is the one who goes through the story in a confused state and inevitably gets everyone into undesirable situations.

The fool is in the story to test the main character. How that character deals with the actions of the fool tells us a lot about that person—for example:

> We are following the shadow character, who is followed by the fool character. The fool character flips the switch to the doomsday device early, and now the whole 5-month plan goes down the drain. In response to the fool's action, the shadow character destroys the fool character in a fit of rage. This then proves just how unforgiving and ruthless the shadow character is.

Or, if the same situation happens and the shadow character doesn't act in a fit of rage but instead tries to fix the problem and still uses the fool character, this would show that the shadow character still has some form of humanity and morality. Therefore, the fool adds depth to the story and provides a window into the soul of the main character. No matter how annoying the fool may be, he or she provides the information we need to fully understand the characters in the story.

From the fool character we move on to something a little bit more interesting: the *anima/animus*. The anima is the female counterpart to the male, and the animus is the male counterpart to the female. This character embodies the male and female urges.

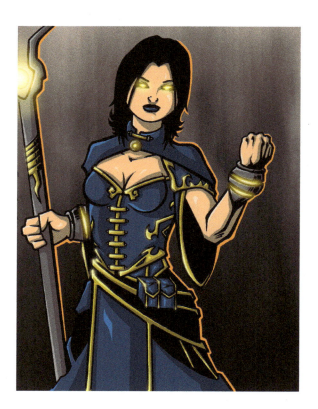

Since I mentioned that there is a counterpart to the female:

These characters represent our sexual desires bundled into one character. In other words, the anima or animus represents the love interest in the story. The love interest doesn't have to be just for the main characters; he or she could be for you, the viewer. How many times have you seen a movie or read a comic and thought to yourself:

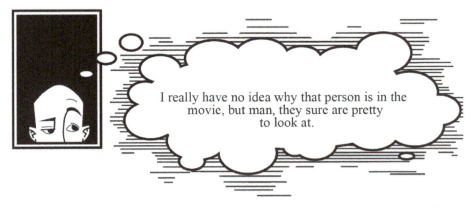

I really have no idea why that person is in the movie, but man, they sure are pretty to look at.

The anima/animus characters exist to draw you into the story. If you or the main character is attracted to the anima or animus character and something happens to that character, it will evoke a wide range of emotions from within. This is another technique to keep you immersed in the story.

Once the main character is emotionally connected to another character—generally the anima or animus—the *mentor* then appears. The mentor is relevant because he or she has the profound knowledge that the protagonist needs even if he or she doesn't want to hear it.

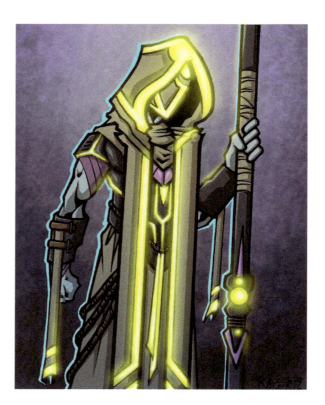

The mentor plays a key role in making the protagonist realize his or her full potential and is often portrayed as an old man or woman. This is because most cultures associate age with having wisdom. The mentor takes on many of the characteristics of a parent. I'll bet that if you think back on your childhood, you can recall that often what your parents told you didn't make any sense, but now that you are older and wiser, you realize they only had your best interests in mind. Remember when I said that the mentor is often portrayed as an old man or woman? Well there are many instances where the mentor character is the same age or younger than the main character.

This leaves us with one final character: the *trickster*. The trickster character is the one that is constantly pushing for change.

The trickster can be on the side of either good or evil. In both situations, the trickster is trying to move the story toward his or her favor or benefit. The trickster has a strong relation to a puppet master, always pulling at other characters' strings, trying to make them do their will. The trickster causes doubt to creep into the main character's mind, making that character change the way he or she was going to handle a certain situation. Generally, it is the trickster's actions that make the main character the type of person he or she is at the end of the story. The trickster is vital to any story because he or she is generally the toughest mental test that the main character has to overcome before the main character can physically and mentally overcome his or her antagonist.

These are the basic character archetypes, but they don't always fit into their stereotypical roles. Take, for instance, the hero and shadow characters. For the most part, these characters are central to the story, but is the hero always the main focus of the story? In this day and age, that isn't always the case. In fact, more and more stories focus on the villain/shadow. That is why the story will focus on the *protagonist* —the main character of the story. Then you also have the *antagonist*, who stands in opposition to the protagonist.

What I am trying to say is that when most people think of a story, they go straight for the hero as the protagonist. That just isn't always the case. If the story is about an evil dictator trying to take over the world, then the antagonist would be the patriot hero standing in the dictator's way of world domination. So, as you can see when you write a story, you need both a protagonist and an antagonist.

I know I have given you examples of each kind of archetype, but I don't know if you understand exactly what each archetype looks like, so I am going to give you some examples from a very popular movie series: George Lucas's *Star Wars*. I hope that if you are reading this book you have seen all the *Star Wars* movies. If you haven't seen them, hopefully you know a little about them. If you don't know anything about them, you should go watch them. Otherwise, this part of the chapter isn't going to help you understand archetypes either.

In all six *Star Wars* movies, I think it is pretty obvious who the hero character is. Luke Skywalker is the true embodiment of the hero character. He stays on the path of good the whole time. Even when he was wandering down the dark path to find out more about his father, his morals and actions were always pure at heart.

He would also put himself in harm's way to help his friends. Even against the wise words of Yoda, Luke went to Sky City to help his friends. One of the best examples of why Luke is the hero character is when he defeats Darth Vader (uh, hope I didn't spoil that for you!) but still tried to save him. Luke wanted to give him the ability to start over and come to the good side.

The one, the only, true bad guy, Darth Vader, is our shadow character. Darth Vader is ruled by emotions. He believes in survival of the fittest. That goes back to the primitive animalistic nature of humans. This becomes very evident in the third movie, where Anakin Skywalker fully turns into Darth Vader. From that movie on we see that Darth Vader acts on the impulses of his emotions, which makes him very susceptible to the influences of the trickster in *Star Wars*.

Only one character in *Star Wars* can justifiably wear the crown of fool, and that is Jar Jar Binks. That character was able to get under everyone's skin. He would always run into something, drop an important device, or flick some switch that would put the entire cast at risk. Jar Jar was the one character whom everyone had to tolerate. He would change the conditions with almost every step he made, making everybody around him adjust to a new situation.

I know there are characters who fill both of these roles, but the character that both the cast of the movie and the viewers would consider the anima is Princess Leia. If you don't know why this is so, Google her character, and I'm sure you'll understand. The character that would fill the animus roll would be none other than Han Solo.

Now, depending on who you want to go with, two characters could be considered the mentor: Obi Wan Kenobi and Yoda. I am going to go with Yoda because he seems to be the one who plays the part of the mentor in most of the movies. Yoda is a good example of the mentor character because he is the one everyone goes to when they need advice. He also always seems to have the right answer, even if he gives it to you in a backward sentence structure.

The trickster character is one many people would argue over, but if you watch all the movies, you will see that Senator Palpatine/The Emperor is the trickster character. He has a really easy time playing the trickster character because he is literally two different characters. So while he is telling everyone what to do, as the senator he is able to manipulate the outcome of every meeting so it will be to the empire's benefit. He is also able to control young Anakin Skywalker and make him join the dark side without even knowing that he was already slowly turning to the dark side.

I hope this helped you to understand archetypes a little better. Now I must point out that any single character can have multiple archetypal traits. Combining archetypes can create more complex and interesting characters, but it can also confuse viewers and readers and make events and plotlines hard to follow. In general, a character designer wants to make sure that the archetypes stay clear and singular solely for the purpose of clarity. This way the viewer or reader won't get confused and lose the magic of the story trying to figure out who is who.

Certain types of stories lend themselves to this blurred archetypal character form. These characters fall mostly into mystery and suspense stories, sometimes even horror. By keeping the character archetypes blurred and confusing, the viewer is pulled into the story, trying to figure out "whodunit." Have you ever watched a movie or read a book and thought:

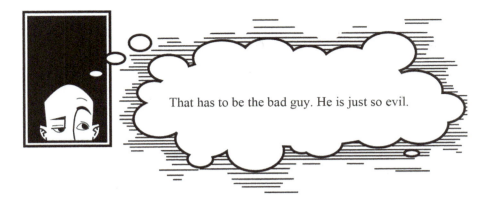

That has to be the bad guy. He is just so evil.

Just to have that thought changed completely as soon as the story moves on:

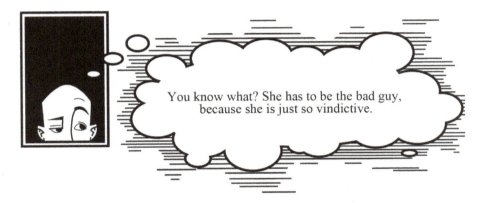

You know what? She has to be the bad guy, because she is just so vindictive.

You were just successfully drawn into the story because you were trying to figure out who did what to whom and why. The blurred archetypal characters forced you to become more involved in the story in order to answer questions raised by this intentional blurring of the archetypal lines.

Man, that is a lot of information, but don't worry we are almost done with the chapter on archetypes. The last thing I want to mention is that archetypes can change at any time. A good guy becoming a bad guy within the course of a book or movie is possible. Even the fool character can become the hero. You need to accomplish this change over the course of the story, not all at once. Your Super Boy Scout hero can't go from saving the day on one comic page to becoming a sadistic mass murderer on the next. All that will happen is that you will lose your reader, and that is just something that you don't want to do.

Archetypes are one of the cornerstones of good character design, but when we overuse the idea of archetypes in its simplest form, we get something completely different. Once a designer tries to simplify an archetype, we start falling into the realm of *stereotypes*. The definition of a stereotype is:

> *A widely held but fixed and oversimplified image or idea of a particular type of person or thing.*

The use of stereotypes is a shorthand used by many designers. The issue when relying on stereotypes is one can fall into lazy character design. Designers will tend to use oversimplified character types, and thus the characters start to show a lack of originality and diversity. One of the most overused and strongly fought stereotypes in the industry is the gender role stereotype. In our current society, typical gender stereotypes like "the damsel in distress" no longer hold true to only being a female character. More and more designers are basing their designs off of the

actual story versus stereotypes. This allows us to have strong female characters, distressed male characters, heroes of different ethnicities, and a variety of villainous characters.

> **PRO TIP!**
>
> **There are also instances where clients will be adamant in sticking to archetypal design choices, and ultimately an artist's job is to give the client the best possible version of what they want.**
>
> —Danny Araya

With that said, the use of this shorthand isn't to be completely ignored as it is a great place for beginner designers to draw their inspiration from. We as humans use stereotyping every day in our lives. We try and fight it, but it is something that we do naturally. Don't believe me? Then I would like for you to think back to a time where you went to a new place, like a school, function, party, anything like that. Now, when you walked in do you remember looking at the new group of people and thinking to yourself:

or

See what I mean. We instantly try to lump people into certain characteristics, stereotypes. This may come as a shock to you, but for the most part stereotypes are not a good thing. They prejudge someone's character without even knowing them, and in character design it is the same thing. If we, as a collective, want to move beyond one-dimensional and repetitive characters and have stronger characters, we will have to move beyond stereotypes, thus forcing the view to be involved in the story and the character beyond the surface.

All of this talk about archetypes and how they affect the story makes me want to get to the next chapter and delve into the character's story. Come on, let's go … oh wait, before we do that, it is time for some homework.

Homework Time!

What's that? You thought you weren't going to get any homework after the first official chapter of the book? Ha ha! Funny. What I want you to do is look at your favorite movie, comic, or cartoon and identify the various archetypes represented within those stories. Once you have identified who you think they are, write them down, and then ask yourself why you believe they are archetypes.

I'll be waiting for you in the next chapter.

The Most Important Part
of Character Design

Did you do your homework assignment? Great! Now it's time for a pop quiz! (Bet you didn't see that coming.)

Define the following archetypes:

> The hero
> The shadow
> The mentor
> The fool
> The trickster
> The anima/animus

Hopefully, you were able to define these archetypes without referring back to Chapter 2. Now that you have committed that information to memory, let's move on.

It is now time to talk about the most important part of character design: story and storytelling. You probably are tired of hearing that, but it is very important and essential to good character design! That's why I think that it is worth saying again. The *most important* part of character design is the *story*! Everything can and will always point back to the story. No matter what character you look at, you must try to figure out the story behind that character. It is human nature to try to pinpoint which category of archetype a character fits in.

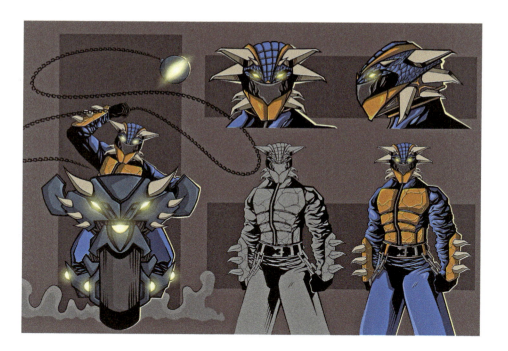

I challenge you to look at any character and not try to label that character a good guy, a villain, a monster, a sex symbol, and so on. It is nearly impossible—unless you are not at all interested in what you are looking at. In that case, the aesthetic is all wrong for you, and, well, that's another chapter in this book.

Take a look at this character. Stare at it for a couple of minutes.

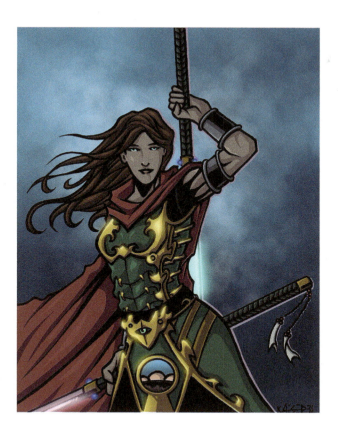

Did you find yourself trying to figure out if this is the hero, the trickster, or any of the other archetypes? Or did you find yourself trying to figure out what her backstory is, what makes her tick, or why she does the things she does? Why do you think that is?

- A Because, we just got done talking about archetypes, and this chapter is about story.
- B Because that's what I told you were going to be doing.
- C Because, as human beings, we are very inquisitive and want to know as much as possible.

If you answered C, then you are on the right track. The main reason we become engaged with a character is that we generally want to know as much as possible about a person. Science established a long time ago that it is people's nature to be inquisitive. If we weren't inquisitive, we would never have had so many advances in science, the works of Shakespeare, or perhaps even discovered the new world.

This is even more evident when dealing with characters like elves, people with superpowers, people in history, or any character who has captured your interest. Most character designers and storytellers use this to their advantage. How many times have you felt compelled to watch an entire TV series or read an entire book or comic series, only to ask yourself:

The answer, once you finally break away from how pretty the character or characters look, is that the designer or storyteller has given you something, be it information or an illustration, that is causing you to ask questions that remain unanswered. So you stick with the character or characters and hope that your questions will be answered.

Now you might be thinking this to yourself:

Be forewarned, however, that withholding information is a double-edged sword. For example, if you have been withholding a certain nugget of information about your character—for example, the ability to conjure up dragons at will—that is probably going to be a cool revelation, and no one should get upset.

On the other hand, let's say you have a character whose past is a mystery, but throughout the story we keep learning more and more about their past. This is what keeps the character interesting. Not knowing exactly *who* the character is adds intrigue and mystery to both the character and the design. But now say you go ahead and reveal everything about this character—where they're from to what makes them what they are, and well, let's face it, all these revelations don't live up to the hype you have created and what the audience has imagined and built up in their minds about this character, and this is going to make the audience pretty mad. You built up all these expectations only to end with a big letdown. If this happens, you just lost your readers because they are no longer invested in the story.

Therefore, you have to be very careful about how and when you answer the popular questions that most people will ask you. What questions are they going to ask? Simple:

- Who?
- What?
- When?
- Where?
- Why?
- How?

I told you it was simple, but if you can answer these six questions with conviction, people will accept your character's story. Now that doesn't guarantee that you will have a good, compelling, and intriguing story, only that you will have a complete, basic story that gives readers just enough information to make them want to know more about your character and what happens next.

Let's try it out. Let's make up a character's story right now, on the spot, and answer the six important questions.

Who? Who is the character in question? Who are we talking about in this character summary?

I am going to create a hero character. His name is going to be the Golden Grasshopper. His real name will be Chuck Johnson.

What? What does this character do in the story?

Let's see. The Golden Grasshopper is a superhero who fights crime with his superhuman jumping abilities that are amplified by the sun. Yeah, that sounds good.

When? When does this story take place?

I am going to say that this story takes place in 1942.

Where? Where does the story take place?

Since it is a beautiful city, I am going to say that the story takes place in Savannah, Georgia.

Why? Why is the character motivated to do what he does in the story?

This is where the meat and potatoes of this character's story are going to come from. So let's see. I think I got something. Chuck Johnson always was a good person. He would do everything in his power to help his fellow citizens. He even joined the military to protect and serve his country.

Tragedy hit Chuck when he grew ill after being exposed to a new form of biological weapon. While Chuck was in the hospital, all he did was read superhero comics. He dreamed of a world where he could be a superhero just like the ones in the comics. When the doctors told Chuck he had only a short time to live, he made a request. He wanted to feel the warmth of the sun one last time. The doctors were more than happy to grant his wish.

As the doctors were wheeling Chuck outside, he began to feel strange. His body felt different, stronger, and healthier. Once Chuck was outside and completely engulfed by the sun, he felt a surge of energy shoot through his body. He jumped out of his wheelchair and, to everyone's amazement, leaped 18 feet into the air. Once the doctors were able to get Chuck back into the hospital and run some tests, they determined that it was a medical miracle. Chuck was completely healed.

The doctors wanted to make sure that the lab results weren't wrong, so they retested them again and again. What they found out was that Chuck's blood had mutated, and it was this mutation that allowed him to jump so high. It was at that moment that Chuck vowed to be the superhero he dreamed about. He vowed to be the pillar of justice in a time of war. He vowed to become the Golden Grasshopper.

The "why" is basically the backstory to your character. You want to make sure that you know what your character's backstory is. That will determine what your character says and does and even how he or she dresses.

How? How does your character do what he does? Sometimes this question can be answered in the why question.

So Chuck Johnson is able to fight as the Golden Grasshopper because of his contact with an experimental biological weapon in the military. As a result of the contact with the biological weapon, his blood has mutated, allowing him to jump to extreme heights.

There you go—an on-the-spot description of a character we just made up. You don't have to believe me, but we did just make that character up. Now I am not saying that this is the best character story, but if you wanted to, you could tell someone else—someone who hasn't read this chapter of the book—about the Golden Grasshopper and convince that person that you know all about this character. Of course, we both know that we don't know *everything* about this character. Right? Right! But thanks to the six questions, we have a good understanding of what the Golden Grasshopper is all about.

Now, you might be thinking to yourself:

I have pretty art. I don't really need to know the backstory of my characters. The art will sell the character.

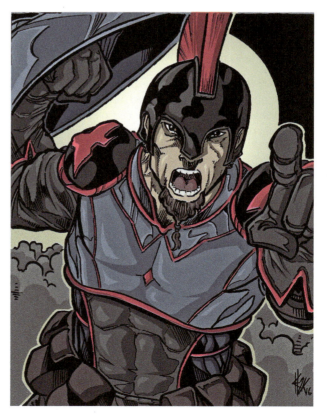

Wrong!

Well, maybe you would get lucky and never really have to talk about your character to anyone, but chances are that after someone sees your wonderful art, that person is going to want to know more about the character. In all my years in this business, I have yet to come across a character design that was so visually pleasing that the story wasn't even necessary. Almost always, when the visuals of a character design stop someone in his or her tracks, the next set of questions is about the character's story. The only time that doesn't happen is when the art deals with a character that has already been established—for example, Spider-Man or Batman. Everyone knows their story already. So, yeah, you really do need to know the backstory of your characters.

PRO TIP!

Drawing your character first will challenge you to create a good story. Develop your story first and that will challenge you to create good character designs.

—David Silva

I actually have an example of when the art wasn't enough. I was at a convention with my studio, and a young man came to my table and wanted to pitch his characters for a comic book. His work was absolutely stunning, and I was instantly hooked. I asked the artist to tell me about his characters, but he couldn't answer the six questions. Needless to say, I passed on this artist's fantastic art because I had no idea what motivated the characters, and since he was trying to get them into a comic book, that information was absolutely imperative.

So as you can see, being able to answer the six questions is pertinent to any good character design. Now I have to admit that I too have created characters without thinking of a story first. I never said that you couldn't create characters without starting with the story, but if you start with the story, it makes things a lot easier in the long run.

Have you ever created a character on a whim and really liked what you came up with? Of course, you have. We all have. At that point you probably decided to keep going with the design of your character. As you started thinking more and more about your character, did things start to change about your character design?

PRO TIP!

A cool design without appropriate context is *just* a cool design. The story is what can allow an audience to invest in your character.

—Chris Scott

It has happened to me, so I am pretty sure it has happened to you as well. What was happening at that point was that your character design was talking to you, telling you about itself. Have you ever found yourself saying this about your character, "Oh, he would never do that" or "She wouldn't say something like that. She just isn't that kind of person"? If so, it means that you are immersed in your character's story, and the more you know about your character's backstory, the easier it will be to create the final design. So why don't we go ahead and do that now.

The following is a development worksheet that I give to my Character and Object Design class. This worksheet will help you to better understand your character. Many different character development worksheets are available, and for the most part they are all trying to get to one final product, so a lot of them have the same information. If you manage to find one that has something on it that yours doesn't, go ahead and add it to the one you use. This character development worksheet is detailed enough to provide a good description of

the character you are creating. Yes, I know there are those that are more detailed than this one, and if you want to use one of those, that is fine as well. The more information you know about your character, the better. Here, I break down what each section is asking and then I answer all the questions for our Golden Grasshopper character.

Basic Statistics

Name:

What is your character's name?

Alias:

Does your character go by a different name in your story?

Age:

What is the character's current age?

Height:

How tall is your character?

Weight:

How much does your character weigh?

Sex:

Is your character a male or a female?

Race:

Is your character Caucasian, African American, Elvin, Dwarven, etc.?

Eye Color:

What is the color of your character's eyes?

Hair Color:

What is the color of your character's hair?

Glasses or Contact Lenses:

Does your character wear glasses, contact lenses, or neither?

Nationality:

What is your character's nationality?

Skin Color:

What is the color of your character's skin?

Shape of Face:

Is your character's face round, square, triangle, oval, etc.?

Distinguishing Features

Clothing:

How does your character dress? High fashion, sloppy, professional, or casual?

Mannerisms:

What unique gestures and movements set your character apart from other characters?

Habits:

What habits, good or bad, does your character have? Smoking, drinking, pencil tapping, cleanliness, etc.?

Health:

What is your character's current health?

Hobbies:

Does your character have any favorite hobbies? Basketball, video games, sniffing glue, etc.?

Favorite Sayings:

Does your character have a favorite saying?

Voice:

What does your character's voice sound like? Raspy, sexy, soft, etc.?

Walking Style:

How does your character walk? Heroic, sneaky, nervous, etc.?

Disabilities:

Does your character have any disabilities, physical or mental?

Character's Greatest Flaw:

What is the one negative thing that stands out above all the rest?

Character's Best Quality:

What is the biggest thing that makes your character great?

Social Characteristics

Hometown:

Where is your character originally from?

Current Residence:

Where does your character currently live?

Occupation:

What does your character do for a living?

Income:

How much money does your character make?

Talents/Skills:

Does your character have any talents or skills that might be useful in the story?

Family Status:

Does your character have any siblings, parents, grandparents, aunts, uncles, etc., and what is his relationship with them like?

Character as a Child:

What was your character's status as a child? Child prodigy, school dropout, petty thief, etc.? Why did your character have that status?

Character as an Adult:

What was your character's status as an adult? King, beggar, genius, ninja master, etc.? Why did your character have that status?

Attributes and Attitudes

Educational Background:

What is your character's highest level of education?

Intelligence Level:

What is your character's IQ?

Character's Goals:

What is one short-term goal and one long-term goal that your character wants to accomplish in his/her lifetime?

Self-Esteem:

When your character looks in the mirror, how does he/she see himself/herself, physically and mentally?

Confidence:

Is your character overconfident, not confident at all, or of average confidence?

Emotional State:

Is your character ruled by emotion or logic or both?

Emotional Characteristics

Introvert or Extrovert:

Is your character an introvert or an extrovert?

How does your character deal with:

- Sadness?
- Anger?
- Conflict?
- Change?
- Loss?

What would your character like to change about his/her life?

Is there anything your character would change about his/her life if he/she could?

Motivation:

What makes your character get out of bed in the morning?

Fear:

Is your character afraid of anything?

Happiness:

What makes your character happy?

Relationships:

How is your character with relationships—social, emotional, physical, etc.?

Spiritual Characteristics

Does your character believe in God?
Does your character have a strong connection to his/her faith?
Does your character live his/her life according to the laws of his/her faith?

Character's Involvement in the Story

Archetype:

Is your character the hero, the mentor, the shadow, or one of the other archetypes?

Environment:

Does the environment affect your character physically or mentally? Does it affect the way he/she dresses?

Timeline:

Describe five important events that led up to your character's storyline. What five events in your character's backstory led up to the current story that will be presented to the audience?

So there you have it! Now I will use this character development worksheet for the Golden Grasshopper.

Basic Statistics

Name:

Chuck Johnson

Alias:

The Golden Grasshopper

Age:

35 years old

Height:

6 feet tall

Weight:

197 pounds

Sex:

Male

Race:

Caucasian

Eye Color:

Baby blue

Hair Color:

Brown; military haircut

Glasses or Contact Lenses:

Neither

Nationality:

American

Skin Color:

A nice California tan

Shape of Face:

His face is that of a hero. He has a square jaw with a butt chin and it is always cleanshaven.

Distinguishing Features

Dress:

Chuck is meticulous about his clothes. His military background doesn't allow him to let himself go, so he is always in khaki pants and a button-down shirt. As the Golden Grasshopper he wears the traditional military boots with long brown pants. He wears a black short-sleeve t-shirt. He has a golden chest plate, golden forearm bracelets, and a golden half mask that resembles a grasshopper's head. He also wears black gloves so he doesn't leave fingerprints.

Mannerisms:

Chuck often cracks his neck as a result of an injury sustained during a secret military mission.

Habits:

Chuck has no bad habits. He is the ideal person.

Health:

Now that he has recovered from his illness as a result of his exposure to the biological weapon, he is enjoying perfect health.

Hobbies:

Chuck loves to play chess. He is always trying to stay two steps ahead of his opponent. Chuck also loves all types of music. Music puts his mind at ease.

Favorite Sayings:

"Holy crap! I didn't know I could do that, too."

Voice:

Chuck's voice is calm and respectful. As the Golden Grasshopper his voice is deep and mysterious.

Walking Style:

He walks very heroically, with his head up and chest out.

Disabilities:

He has mutated blood that is affected by the sun.

Flaws:

Chuck believes that he isn't doing enough to help humanity.

Best Quality:

Chuck's best quality is that he values life over all other things.

Social Characteristics

Hometown:

San Diego, California

Current Residence:

Savannah, Georgia

Occupation:

Superhero

Income:

Since the government funds the Golden Grasshopper, he is able to afford anything he wants.

Talents/Skills:

Except for the skills he learned in the military, Chuck doesn't have any other special skills or talents.

Family Status:

Chuck is a family man. He enjoys a great relationship with his parents. They don't know that Chuck is the Golden Grasshopper. He is also very close to his younger sister and is helping her and her infant son since her husband left her. She also doesn't know that he is the Golden Grasshopper.

Status as a Child:

He was just an ordinary kid.

Status as an Adult:

As an adult, Chuck Johnson is the Golden Grasshopper, the defender of justice.

Attributes and Attitudes

Educational Background:

Chuck graduated from high school.

Intelligence Level:

Chuck's IQ is 109.

Goals:

His short-term goal is to figure out what he is capable of doing with the new powers he has. His long-term goal is to uphold justice, stop all evil, and bring peace to all.

Self-Esteem:

Chuck sees himself as a superhero who isn't doing enough with his gifts.

Confidence:

Even though he thinks he isn't doing as much as he could now, he is very confident that one day he will.

Emotion:

Chuck is a very logical man, but in certain life-threatening situations his emotions take over completely.

Emotional Characteristics

Introvert or Extrovert:

Chuck is an extrovert.
Chuck deals with sadness by immersing himself in music.
Chuck is quick to throw his fists when he gets angry, but it takes a lot to make him angry.
Chuck deals with each conflict very logically. He always thinks before he acts.
Chuck thinks change is good. If it wasn't for change, he would be dead now.
Chuck deals with loss like most people. He reflects on what he lost and hopefully is able to move on in time.

Goals:

Chuck is completely happy with the way his life is now. The change already happened, so now he has to make the best of the hand he has been dealt. He plans to put his powers to good use, not just for himself but for everyone.

Motivation:

Chuck always wanted to be a superhero. That is why he joined the military. Now that he has superpowers, his main motivation is ultimately to create peace for everyone to enjoy.

Fear:

Chuck's biggest fear is failure. Now that he has been granted this gift, he doesn't want to fail the people who depend on him.

Happiness:

Knowing that he is making the world a better place puts a smile on Chuck's face every day.

Relationships:

Being the family man that he is, Chuck is really good with people. Everyone seems to like him. If there is someone whom he can't get along with, that generally means that person is evil at heart.

Spiritual Characteristics

Does your character believe in a supreme being? If so, whom?
Chuck believes in God. Does your character have a strong connection to his/her faith?
Chuck's moral compass is directly connected to his faith. That is what kept him humble in his time of sickness and is the main reason he believes he has been blessed with these powers.
Does your character live his/her life according to the laws of his/her faith?
Chuck is not a religious fanatic. He believes in God and tries his hardest to live by his commands.

Character's Involvement in the Story

Archetype:

Chuck is without a doubt a hero type.

Environment:

The environment is the main reason why Chuck is the Golden Grasshopper. Without the sun he would still be sick. The sun is the source of the Golden Grasshopper's power. The government designed his armor to act like mini solar panels so he won't lose his powers on overcast days.

Timeline:

The story takes place in 1942. The following five events led up to Chuck's storyline:

- Chuck Johnston was one of the few soldiers who were inducted into the special military detail. He would be the military's secret weapon against the enemy.
- Chuck was exposed to an experimental biological weapon that was being used by the enemy on a special mission. When he came into contact with the weapon, he became ill and had to be transported to the hospital.
- The doctors at the hospital worked hard to find out what Chuck had and how to cure it. It was here that Chuck rekindled his passion for comic books. As he read them, he dreamed of the day that he too could be like one of the superheroes in the comics.
- Chuck was told that what he had was incurable and that he only had a short time to live.
- Chuck asked if he could go outside to feel the sun on his body one last time. When the sun's rays hit him, he started to feel different, stronger, and healthier. He felt a surge of energy shoot through his body, and he was able to get out of his wheelchair and jump 18 feet into the air. Once the doctors were able to get Chuck back into the hospital, and run some tests, they determined that it was a medical miracle. Chuck was completely healed, and a short time later he decided to protect and serve as the Golden Grasshopper.

Phew! That was intense. I don't know about you, but I feel pretty darn good about the development of this character. I am sure that after watching and reading the development of the Golden Grasshopper, you are just itching to get started on your own character. Well, go right ahead. You can use the character template at the back of the book.

Homework Time!!

That's right you guessed it, your homework is to fill out the character sheet anyway, so you might as well get started. I will see you in the next chapter.

Can You Still Be Original Anymore?

Did you have fun with your homework? I sure hope you did, because if you didn't have fun creating the story for your character, then I think it is fair to say that character design might not be for you. If you did have fun, I have a question for you: Did you find yourself trying to come up with a completely original story? You know, one that no one has ever read before. If you were indeed trying to come up with something original, did you have a hard time doing it? I have a good feeling the answer is yes. Do you want to know why that is?

To be *original*, you have to come up with something no one has ever done before. The reason it is so hard to be original is because humanity has been on this planet for quite some time, and during that time a huge number of ideas have been thought of and brought to fruition. Those creations are what inspired generations of people such as artists, architects, actors, writers, musicians, and many others to create the great things they did. So if you look throughout history, you will see that most, if not all, ideas have already seen the light of day.

Now I am not saying that there will never be an original idea ever again (I just hope I am around to witness it), but I'm just saying it is going to be extremely difficult. So you shouldn't be obsessed with creating anything, let alone a character, with the assumption that it absolutely has to be an original concept.

During my years as an instructor and lecturer, I have often asked my audience, "What is an original idea that you have seen in your lifetime?" So far, no one has been able to come up with anything original. So then I pose the question, "What do you think was an original idea?"

I heard some good thoughts, but for the most part what people thought was original could be traced back to something that had already been created. For example, an audience member at the San Diego Comic Con brought up comics. Well, first you have to look at what comics are. They are a series of images that tell a story. You can go straight back to the time of the caveman and look at prehistoric cave paintings, and there you go—the first visual narrative! That's right—a comic.

While we are on the subject of cavemen, do you know what a genuine original idea was? The wheel! Many other inventions started with that one. Can you imagine what our world would be like if the wheel had never been invented? It would be interesting, but that is a different topic altogether, so let's get back to talking about originality.

As I said before, it is hard to be original. So my advice is to make sure you have some form of *originality* in everything you create. It is a lot easier to obtain originality than to be original. All *originality* means is that you have taken something that already exists and added your own super-awesome twist to it. Now I know what some of you might be thinking:

Well, let me tell you something that I was told a while back. Once upon a time there was a very smart and wise individual who said, "A smart man borrows and a genius steals." (Please don't take that the wrong way and steal your best friend's TV. That's not the point.) What this means is that we are all inspired by the things around us. If we like something, we want to see it again and again. That is why, when we are in the creative mode, we generally pull all of our inspiration from the things we think are cool. What lets us get away with "stealing" those cool things that already exist is that we add our own twist and give them originality.

Here is a little scenario of what might happen to you as an artist to put this idea of originality to the test. Let's say you are working at your art desk and you get a phone call. Somebody would like you to develop the next big character for his or her company. You are very excited about this opportunity, and you ask what the character should look like. All you get back from the caller is that the company is looking for a robot. You say fine and hang up the phone. A couple of hours later you've developed this:

The company is thrilled with what you came up with and asks you to design another character. The conversation goes something like this: "We loved your character design so much that we want to work on another story. The new story is going to be about another robot, but it should be different from the first one—just as cool, but different. Do you understand?" Now you are sitting at your desk and thinking, "What can I do for this character?" After a while, you come up with this:

By now you are feeling pretty good about your ability to design interesting robots, even though you would rather not have to do it again for a while. Well, Murphy's law prevails and you get a call from a different company. They loved what you did for the other company and they want a robot as well. Something that is reminiscent of what you did for the other company but different. So, with much dismay, you get to work and develop this:

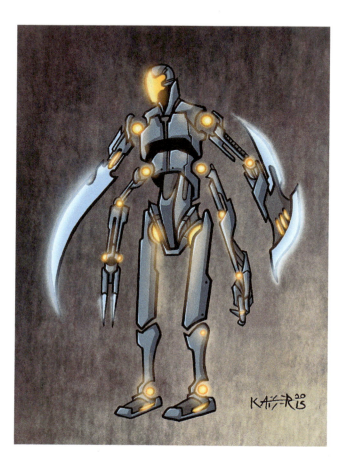

Now after the third similar but different robot, you start thinking to yourself that this is getting a little old and hopefully no one will want another robot for at least a couple of years. Later, when the phone rings, you have this sinking feeling that someone is going to ask you to draw another robot. Well, you were right. You drag yourself to your drawing table and come up with this:

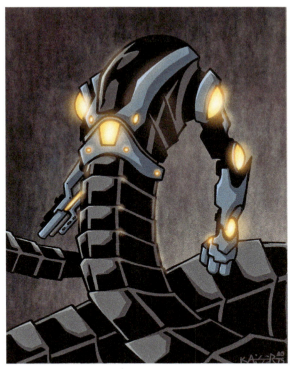

As you finish your last robot, you realize that there seems to be a robot revolution going on and you are the main reason why. But then you remind yourself that the money is good, so you are going to keep designing robots if that is what everyone wants to see. Now you are being hailed as the robot designing king or queen, and no one doubts your robot design skills. You think to yourself that you will design one last robot and then retire. You sit at your drawing table and draw this as your final goodbye to the creation of robots:

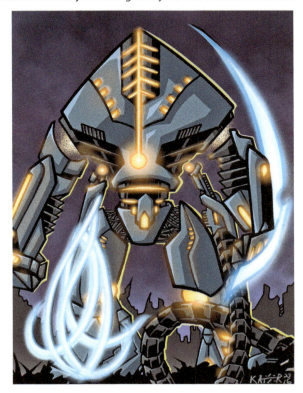

I hope this story made you realize that even with a very simple description like "robot," you can come up with many different designs. Not to mention you were also able to take what you already drew and build on it. You were able to put your own twist on a character design over and over again. Were you able to see that? If you did, that's great. If you didn't, then I am going to have to try harder and tell you the story of Jim and the toaster.

There once was a man named Jim. Jim was a normal man who loved eating bread. One day, while looking at his loaf of bread, he thought to himself, "There has to be a better way to have hot bread without having to wait for the oven to heat up and having to bake the bread."

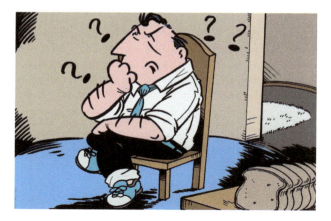

So Jim sat in his living room and thought and thought and thought. He sat in that chair for hours and then …

he had a great idea. "I will invent a toaster—a small, ovenlike box that once plugged into the wall will be able to heat up my bread in a matter of moments. This is going to be awesome!" Jim thought to himself.

So day in and day out, Jim worked on his invention. He had never worked so hard on anything in his life, but he knew this was going to be one of the best things he ever did.

One day while Jim was taking a break from working on what he thought was going to be the greatest thing since sliced bread, he received some very frustrating news.

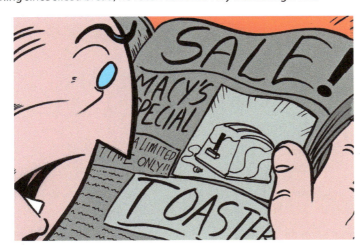

Someone had already invented the toaster and had sold the idea to Macy's! All that time and effort for nothing! Jim was beside himself.

Needless to say, Jim was very mad. He had some choice words for Macy's *and* the newspaper he was reading. Once he calmed down, however, he started thinking about how he could still make something out of all the work he had put into his toaster idea.

Then it hit him: "I've got it! I didn't waste all my time working on the toaster. I will just modify it and create the *double toaster*!"

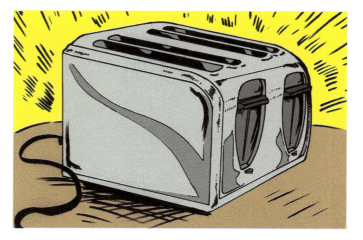

After Jim introduced his double toaster, someone else thought he had an idea…

and used Jim's creation to create the *double muffin toaster*!"

Then, after the double muffin toaster was on the market, somebody thought they had a great idea on how to capitalize on what had already been created

and produced the *muffin and egg toaster*!"

Now do you see how adding your own twist to something that already exists is something that many people do? Why wouldn't you take something that you like and try to make it better? Did you notice the other important message in this story? If not, read it again and see if you can find it. Go ahead, I'll wait.

Wow, you're back already? Did you figure it out? Well, in case you didn't, I'll tell you, and if you already know what I am going to say, then I am just going to validate what you already know. At the beginning of the story Jim had this great idea and started working on it right away, but before he could get it finished, someone else completed

the invention and sold it to a major company. What does that tell us? It tells us that there are many great ideas out there in the universe and even more people grabbing at those ideas. Have you ever heard the saying "Great minds think alike?" It's true, and you might take it as a compliment—until you are working on a project for a long time, only to have someone come out with the finished product before you do. That doesn't mean you should just give up. Not at all! It just means that once you have a good idea, you have to hit the ground running and finish your project to the best of your ability as fast as you can.

I mean, think about it, how many times have you thought:

or

Here is a little story about an experience I had with one of my students. I gave the class a simple assignment to draw the most bad%$# character they could think of. Knowing how easy it would be for them to just look around and copy something they liked, I told them the character had to be an original creation. That threw a monkey wrench into a lot of people's plans, but alas the students went off to create their characters and present them the next class.

The next day, the class started and things were going just fine. The students presented their characters in front of the class. Some were good, and some were not so good. For the most part, however, they all showed evidence of originality. Then came the student who was going to change all that. With confidence he strolled to the front of the class. He gave us a description of the character's backstory and finally revealed the character.

When he showed the class his character, the silence was deafening. Then the rest of the class started looking around at one another and started whispering, "I have seen that character somewhere before."

The problem was, they couldn't remember exactly where they had seen it, so they didn't say anything. It was up to me to let the student know that this character had been done before. He insisted that it was completely original. Now, with what you have already read in this chapter, you should know that the student's claims weren't going to bode very well with me.

I proceeded to tell him how a female winged demon with a tail had been done by many artists in a multitude of stories. Even after I told him where to find them, he refused to acknowledge that anyone had created this character before. So I took it one step further and told him that he should have done some research first because that character also appears in various types of mythology.

At this point, the tension in the room was so thick you could cut it with a knife. The final straw came when he admitted that the character was not original, but the weapon that he had created was completely original and that no one had ever seen anything like it. I had to tell him that he was wrong yet again. The weapon he had drawn had indeed been created before. Known as a *sai*, peasants in Okinawa, Japan, used it as both a weapon and a farming tool. (Most people are familiar with it in the hands of Raphael from the *Teenage Mutant Ninja Turtles*.)

The moral of this story is, an original idea is very hard to come by, and even if you are just putting your own twist on a previous creation, make sure you get it down on paper fast and post it somewhere with a copyright because someone out there is probably working on the same thing. Also, always make sure you research the subject matter you are working on (this is covered in Chapter 6). It is really hard to put your own twist on something if you don't know what already exists.

> **PRO TIP!**
>
> **Don't be lazy and just copy. Take what you like and make it your own.**
>
> —Bun Leung

This subject of originality versus original is a touchy one. In the end, one must understand that we are always being influenced by the things that are around us. In this day and age, we are bombarded by new and fascinating information all the time. With the invention and ease of Internet use, it is almost impossible to not be influenced. Well, I mean you could disconnect the Internet or never look at your phone again, but let's be honest, who's going to do that? With that said, I try to inform and motivate my students to absorb everything and use it to your advantage. If a designer likes an array of different things and thus is influenced by a bunch of different things, when it comes time for them to create, they are going to try and incorporate (steal) all the things that they like and are influenced by, thus creating with the idea of originality and not trying to be original.

> **PRO TIP!**
>
> **A good artist borrows; a great artist steals (if you need me to explain this, hit me up).**
>
> —Bakia Parker

I hope that after reading this chapter you completely understand the difference between being original and having originality. I feel your head nodding, so why don't we put that knowledge to the test.

Homework Time!

Take five characters you enjoy looking at and put your own twist on them. See what you can come up with and try to have some fun with it. Try not to overthink things.

What are you waiting on? Go on, get to work. I will see you in the next chapter.

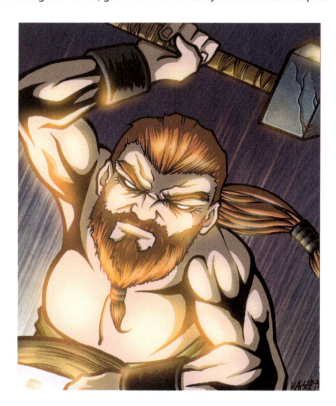

Shapes and Silhouettes

Did you have fun with the last assignment? Hopefully you didn't overthink it and make it harder than it had to be. In any case, I'll bet that while you were applying your personal twist to the characters you picked, you were happy to know that professionals do the same thing all the time.

Let's move on to something a little different. Now I want to talk about shapes. I'm sure you already knew that because the title of this chapter mentions shapes. I know what you are thinking:

How can shapes possibly help me with my character designs?

Well, I'm glad you asked that question (if you didn't, you should have). Shapes are what we fundamentally use to define what certain things are and what they possibly can be used for. If you don't believe me, look at it this way. If cavemen had decided that a square was better for

mobility and movement, we would be using squares on our cars instead of circles. Luckily for us, they decided to go with the circle. But as long as we are talking about squares, let's look at one.

So what do you see here? I hope you see a square, but what does this shape tell you about itself? If this shape was the dominant shape in your character, what would it say about the character? Any ideas? Generally, when we look at a square, certain terms should come to mind:

Stability
Trust
Honesty
Order
Conformity
Security
Equality
Masculinity

These are the most common things people think about when they see a square shape. It is important to know this kind of information when making characters because you don't want them to suggest something they are not.

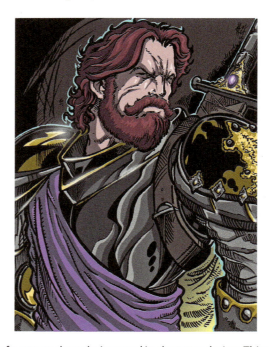

Here is an example of a square shape being used in character design. This character has a so-called square jaw. Despite the facial hair on this character, we can see that the shape used for his head is that of a rectangle, a square shape, and that is giving off a sense of strength and stability. Now that you know some of the meanings behind a square, do you see any of them in

this character? I know that you might be thinking, "Well, look at that pose and that armor and that sash; of course, he is going to look that way," but I can tell you that if you put a different shaped head on the same armored body, it would give you a different feeling all together.

At this point you are probably going through all the shapes you know and trying to figure out the meanings behind them. Or you might be trying to figure out if this works with any other shapes. Let's try it.

What do you see here? That's right, it's a triangle. What do you think the triangle is trying to convey? Once again, generally speaking, a triangle conveys the following:

Action
Aggression
Energy
Sneakiness
Conflict
Tension

I don't know how many triangle people or character designs you have seen, but the triangle shape is present in people's faces. Take a look at this next character and see if any of the meanings are evident in the character design.

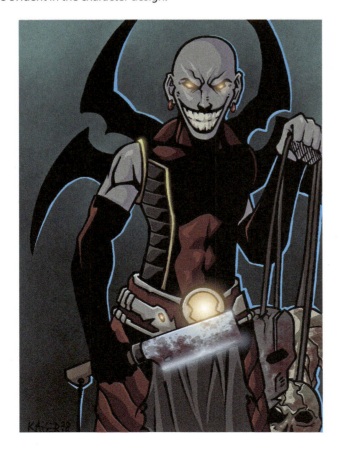

Do you see the triangle shape in his face? What did you think about the character when you saw him? Did it match up with some of the meanings that were mentioned earlier? When thinking of characters with a triangle shape for a face, we tend to think of villains. The reason for that is because the pointiness of the upside-down triangle gives us a feeling of uneasiness. The slope of that shape makes us think of danger.

Here is where it starts to get a bit tricky, and this shape is one of the easiest ones to demonstrate what I would like to show. As I mentioned before, there are multiple things that are represented with every shape. Even though you are using a triangle, it doesn't mean that the character has to instantly be evil. The problem that we face is that we as a people have decided that a pointy face means the bad guy, which is something that you can use to your advantage when designing a character. Take a look at this character.

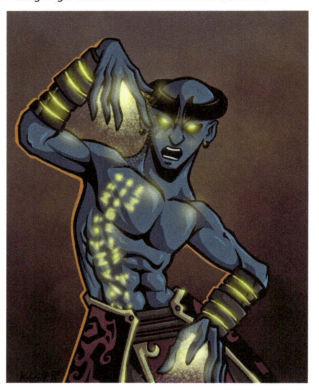

This character may look like he is the bad guy of the story, but he is not. His design is using some of the other meanings of the triangle: action, energy, and tension. The tension comes from the fact that he looks like the bad guy, so in the story everyone treats him that way when they first meet him. This allows for conflict within the story and depth to the character and the characters he interacts with.

Let's do one more for good measure. What do you see here?

Can you think of some of the meanings behind a circle? What do you think a circle could possibly be telling us about itself? If it could talk, it might tell you that a circle can be viewed as:

Completeness
Gracefulness
Playfulness
Comforting
Unity
Protection
Childlike

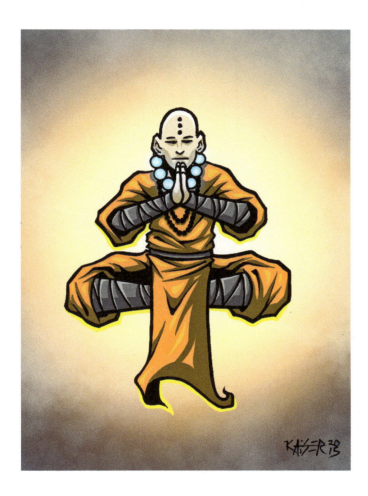

Do you see the circle shape in this character's face? Do you see any of the meanings in this character? The repeating use of circles gives us a feeling of calm, completeness, and even protection. Once you get away from the face, the shapes change, but since the face is such an important aspect of the character, it becomes the most dominant shape and we start to associate certain attributes with the shapes of the face.

Some students have told me that these meanings aren't really the focus of a character. That is fine, but you have to know that, depending on what shapes you use, you might be telling a different story with your character designs than you think you are. So it's a good idea to remember the meanings behind different shapes for future reference. Trust me; you'll be glad you did.

Shapes don't just play a role in a character's face, but in their body as well.

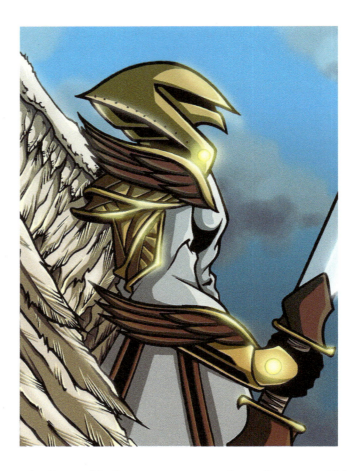

When you were looking at this character, were you trying to figure out which meanings were being represented? Was it harder to do than with faces? When you start embellishing the shapes to make them more interesting, you must always keep in mind what the basic shapes are saying. No matter what else you do to the basic shape, it will always be the most prominent feature. So, for example, if you have rounded triangles like the previous character, most people will interpret that as a form of protection that allows the character to be aggressive. So you have both a protection meaning from a circle and an aggression meaning from a triangle. Cool how that worked out, huh?

At this point you might be asking yourself this question:

How am I supposed to find the shapes that work best for my character?

Well, as long as you know what you are trying to say about your character, you will know what basic shape to use for your character. You are probably going to want to augment some of those shapes to make them cooler looking. The best way to do that is to use a silhouette.

A silhouette is an outline of a character that is filled in with black. It kind of looks like a shadow.

PRO TIP!

As a character designer, your entire job is to make sure your character design is clear, interesting, and relevant to the story and/or game design experience you're creating. Strong silhouette is probably the most effective way to deal with all three of those design challenges.

—Danny Araya

Silhouettes are important in character design for one reason: recognizability. If you can create a character with a combination of shapes that is completely recognizable when it is in complete shadow, then you are doing something right. Having a good silhouette will allow your character to stand out among the sea of characters that will be in the story.

Also, when thinking about the audience that you are making these characters for, the easier the character is to recognize by just basic shapes, the more memorable and less forgettable they will be. That will always hold true as long as you don't break the form follows function rule. (Don't worry, we are going to talk about that a little later in this chapter.) Try to think of some characters that have good silhouettes.

I'm sure you were able to think of some good ones, like Batman or the Simpsons, but I have one that trumps them all. This character has the best silhouette of all time. Interested in knowing who it is? I'll give you some clues:

> This character is a he.
> He likes dogs.

Any thoughts? You still need some help, don't you?

> He doesn't wear a shirt.
> He is represented by three circles.

How about now? Still nothing? Okay, here is one last clue:

> He lives in a magical kingdom.

I hope you know the answer by now. If for some reason you still couldn't figure it out, ask someone who has little kids who has the best silhouette in the world. Give them all the same clues, and I'll bet they'll be able to tell you who it is.

Once you figure out who the character with the best silhouette is, you should be able to see how much a strong silhouette can help with recognition. Using a silhouette is also a very good starting point for character design. With a silhouette, you can make multiple designs in a very short amount of time because you aren't really focusing on the finer details of the character. (If you insist on putting details in your silhouettes, you can use a few white lines to help you.) Here are some examples of using silhouettes and white lines:

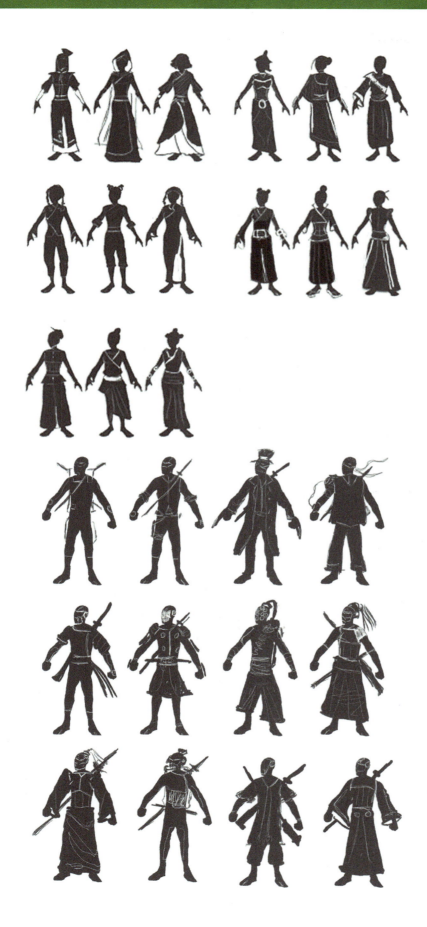

PRO TIP!

A strong silhouette can tell you *everything* about a character.

—Chris Scott

Try not to overdo it because you want to concentrate more on the shapes you are going to use and the functionality of the character. Remember what I said about form follows function? What that all boils down to is that no matter how cool your design looks, it should always look like it would *work*. I have to say that artists not following this rule is one of my biggest pet peeves.

You have probably seen character designs that you liked visually, only to think this after further examination:

As a character designer, you *never* want to hear that question asked about your designs. Why, you ask? Elementary, my dear Watson! If a person has to ask that question about your design, it is going to pull that person out of the story you created and destroy any allure that you might have had for your character. You don't want that to happen, do you? I didn't think so. Just in case you still don't know what I am talking about, I would like to show you. Let me give you some examples using three different form follows function items:

 Spiked arm bracelets
 Four-arm mutations
 Robots

In the 1990s, character designers seemed to use spiked arm bracelets a lot. The whole idea behind the bracelets is actually pretty cool. A character has spikes around his or her biceps, and every time he or she flexes, you see spikes. It makes for a very intimidating look. The biggest problem that most young designers have is that they put spikes all around the bracelet, like so:

If you don't see why that is a bad idea, let me tell you why. If the bracelet has spikes all the way around, every time a character puts his or her arms down, he or she is going to get stabbed! This is a design flaw, and it doesn't follow the form follows function rule. So if you are going to have spiked arm bracelets, you want to make sure there aren't any spikes on the inner part, like so:

I know it's a simple solution, but it's the solution to the problem. Why don't we look at something a bit more challenging: the four-arm mutation? Everyone wants to create a character who can hold more weapons than a normal human, so naturally the character is given more arms. It's not a bad idea, but when designers try to attach extra limbs to a human body without thinking about the form follows function rule, they get into trouble. This is what I generally see when students and young character designers approach this design challenge:

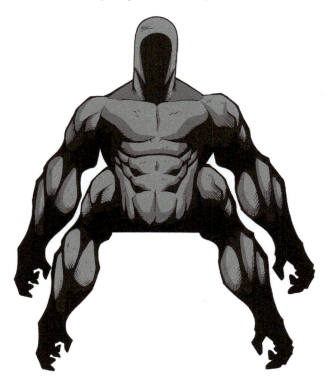

As cool as this might look, there is a big problem with this character. Because this character does not conform to the normal human skeletal system, it doesn't follow the form follows function rule. As it appears now, it can't move the second pair of arms.

If you don't believe me, look at a picture of a human skeleton. Notice that the arm is connected to a ball and socket. The head of the humerus fits into the socket of the scapula, which allows the arm to rotate. The scapula has the acromion process and the coracoids process, where muscles attach to help move the arm. Then there is the clavicle, the suprasternal notch, and the sternum, which all have muscles attached to them. And let's not forget the rib cage, to which muscles are also attached. All these things are required for an arm to be capable of movement. If we just slap on a couple of more arms, there would be too many other vital parts missing. So how can we fix this design problem? It's simple, actually. We just have to double up on everything that is needed to make the arms work. In short, we need another torso, kind of like this:

I know it looks a little funky, but it's what we need for this character to actually work. Not all design choices can follow the form follows function rule. Sometimes you need to know when to walk away from a design you have created.

Another character design where people can forget about the functionality of a character is an angel. Most designers just put wings on the shoulders or coming out of the back.

You know from the arms example that this wouldn't work. The wings need to be part of the skeletal structure to function, and without elongating the body, that just isn't possible.

PRO TIP!

I believe in the notion that "form follows function" and that a character/object's physical appearance is contingent on/informed by the necessity of their apparel and/or accessories in their life or story.

—Colin Byrd

The last thing I want to talk about is robots. I know that robots are probably the coolest of the four examples, but they are the easiest to screw up as well. Robots are basically big moving shapes. For these shapes to move, all the parts have to work together. Remember the toy where you put the square block in the square hole and the star shape in the star hole? That's pretty much the same way robots work. The shapes have to work with one another for the robot character to be believable. You can't force a star shape into a square hole unless you break it. Robots, at their core, are the epitome of form follows function. Or at least they should be.

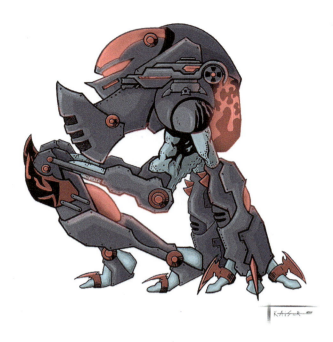

Do you see how the shapes on this robot character interlock? They are working together to form a believable character design. When using multiple shapes to create an interesting character, it is imperative that you can visually show just how they would work together without having the viewer confused as to how they are supposed to work.

> **PRO TIP!**
>
> **Remember to *always* balance form and function. Anything too much to either side and you'll end up too flashy or too boring.**
>
> —Chris Scott

I hope you can now see how form follows function is supposed to work. It is simple when you think about it. Whether you are designing angels, cops, robots, ninjas, or anything else that you can think of, just remember that whatever you create has to look like it would work; otherwise, you cause the viewer to question whether your character is believable, and that is what pulls people out of the story and that is just no good.

That's my soapbox when it comes to shapes, silhouette, and form following function. Now, on to your homework!

Homework Time!

Go ahead and design a character and then change the primary shapes in your character. See if that changes anything about your character. You might discover that simply changing the shapes gives your character the story you were looking for. I will eagerly await you and your homework in the next chapter.

Reference, Reference, and Reference—Oh My!

Since you're here, apparently I haven't scared you off yet. Did you do your homework? I will just have to take your word for it, because there is still more to be told about character design. So let's move on, shall we? The next thing we are going to talk about is reference. *Reference* is defined as "an act or instance of referring." I don't know about you, but when the definition of a word uses the word to explain its meaning, I don't think that's much help. Reference for character designers can be defined as "the ability to observe from life or from a photograph to ensure that what is being portrayed is visually correct."

To clarify that definition a bit, I'll give you an example. Say you have designed your main character, and his sidekick is a bobcat. To ensure that your portrayal of a bobcat is correct, you would need a reference. To obtain a good reference, you could go about it a couple of ways. You could go to the zoo and draw or take pictures of a live bobcat. Or if by chance you have wild bobcats in your backyard, you could draw or take pictures of them. Or—and this is what most of my students do—you can just go on the Internet and do a Google search for "bobcat" and use other people's photographs and drawings.

When I start teaching the topic of references, some students get these crazy ideas in their head:

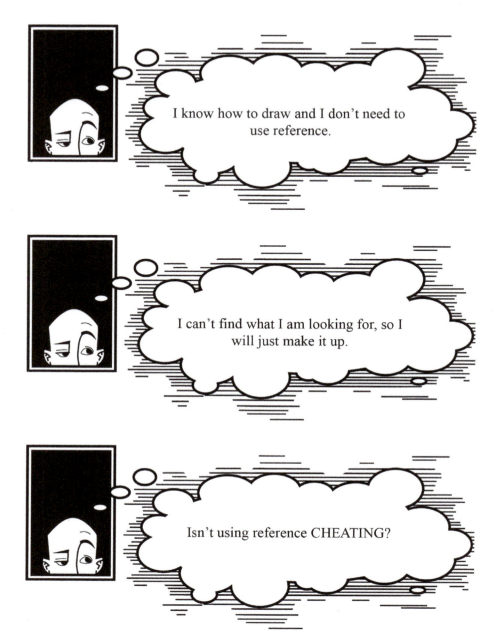

Did you have some of the same thoughts? If you did, you need to get them out of your head right now! It doesn't matter how much you think you know how to draw, you can always use references. If you can't find exactly what you are looking for, keep looking; it's out there—I promise. And using reference is definitely not cheating.

> **PRO TIP!**
>
> **Reference is pretty much essential if you want to create things that are functional or believable.**
>
> —Enrique Rivera

All professional character designers use reference. Just watch the special features of most animated movies, and you will see the artists—the "pros"—using reference! Whether you

are revamping old characters or creating brand new ones, references are vital because you have to make sure that everything on your character is accurate.

Reference……..... got it!

Drawing people is a great example of what I'm talking about. A large majority of character designs involve some form of the human body. The best ways you can ensure that your designs are correct is with reference and practice—and then probably more reference. The best source of practice and references will always be life drawing. What's that you say? Life drawing isn't the same as reference? Au contraire, young grasshopper. When you draw from life, you are referencing the real world around you. You have to look at what you are drawing to make sure that what you are drawing is correct. To prove my point, here are some sketches from a life drawing session.

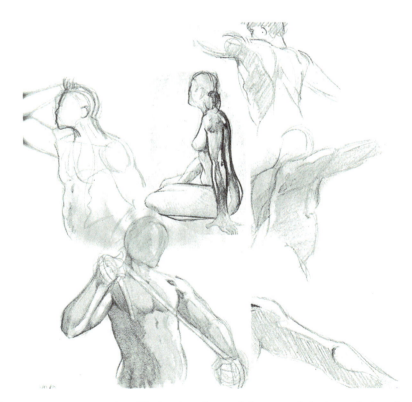

I realize not everyone can take a life drawing class and draw people in the nude. It makes some people a bit uncomfortable, and, let's face it, you would have to pay to get into a life drawing session anyway. So what's the next best thing? Wait! No! No! No! Don't go there! I'm talking about drawing the people around you. Everywhere you go, there are people you can

draw—on the bus, at school, at the bowling alley, the friends playing video games with you. The reference you need is all around you. (I personally like drawing people on the Metro train.)

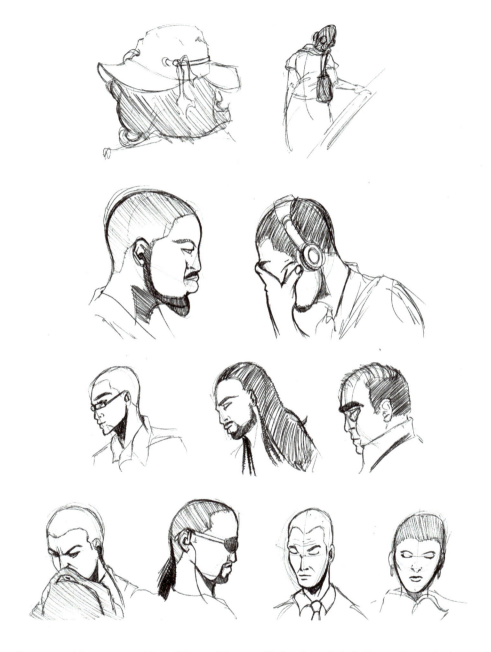

See, everything you need is walking, talking, and living lives right in front of you. And once you understand human anatomy, you should probably learn to draw people with their clothes on. (Let's face it. How many characters have you created in the past that walk around living out their lives naked? Exactly.) Let's not forget that you don't just have to draw people. There are plenty of characters that are out that are based on animals. Yes, you could get reference from the Internet, but there is no substitute to observing animals out in the wild.

Even though I just mentioned animals, I bet you have this thought running through your head:

I can't draw people on the bus, they move too much.

Well, that might be true, but you have to try. Drawing people who are moving gives you practice at remembering what it was that you were looking at. This is also known as developing your visual library. It is a good skill to have. After you draw for a while, you will notice that you are able to fill in the gaps, but that will only happen if you practice. The more that you draw, the more that your visual library grows and you will be able to call on the information when it is, let's say, moving.

Another great skill you will learn by drawing people on the bus or walking around in the mall is gesture drawing. Gesture drawing is a form of quick drawing that allows you to focus on the motion, energy, pose, and mood of what you are drawing. These drawings will make you draw faster so you can capture the energy, pose, and mood of the people in motion. If you can become proficient in gesture drawing, your character designs have less of a chance of becoming stiff and lifeless.

PRO TIP!

For the student or novice, however, observation from life will generally produce better habits and better results long term.

—J. P. Mavinga

If you are still intimidated about drawing strangers on the bus or in the park, you could draw your friends. They are people that you already know and shouldn't feel nervous around. Now it might just be a bit awkward for them to be drawn or stared at to be drawn, but what you could do is have them get into a pose that you need for your character and take a picture. Taking photo reference is a great resource for all levels of character designers. Not to mention you would be able to direct them into exactly the pose you need. Your friends are a great resource for great poses.

Now if you and your friends are still feeling a bit awkward around each other when it comes to the artist model relationship, then I know someone with whom you will always feel comfortable and who will always be at your beck and call. This individual will pose any way you like for as long as you want. And the best part is, this person won't complain. Well, they won't complain enough for you not to use them. Are you ready for this great resource? It's *you*! That's right, you. You are the best model you will ever have. You will always be there, and you know exactly what you are looking for. Here are some examples of me being my own model.

The best way to draw your entire body is to use a full-length mirror. They aren't too expensive; 10 to 12 bucks tops. Drawing yourself can also teach you how to remember what you see because, believe me, as great a model as you might be, you are still going to move.

With yourself as the model, you can pretty much have any type of reference pose you want. Of course, it will be hard to hold still while you are drawing, so you might want to get one of your friends to take a picture of you posing. You can take a camera with you wherever you go, and thanks to the invention of tablets and smartphones, viewing your photographs couldn't be easier. The Internet is also a great resource for photo references. You can download millions of pictures that other people have taken.

Being able to get any person to hold any pose for an infinite amount of time is invaluable, but there is a downside to photo references. Can you guess what it is? What? Wait … no, the camera isn't perfect. There is a problem with photo reference. The problem with photo reference is that the camera makes all the choices for you. The camera's job is to take the three-dimensional world we live in and make a two-dimensional representation of it. Just in case you didn't know

it, if you draw at all, that is your job, and if you are going to rely solely on how the camera stylistically flattens out the world, then you can just use the camera instead of real life, right?

I am sure that at this moment you are thinking to yourself:

A camera can't do what I do. I have a unique style.

Yes, you *are* unique in every artistic way, but if you let the camera dictate what and how you are going to draw, then the camera is the artist and not you. Let me give you an example.

I once had a student who turned in a final project that looked absolutely amazing. The details, the story, and the color were spectacular. Once I got past the outer beauty, however, I realized that the perspective was completely off. When I mentioned it to the student, his explanation was, "That is what the picture looked like." I in turn said that it doesn't matter, it still isn't right. This student was a slave to his photographs. He was able to make the picture look really good, but the camera had warped the perspective, and the student had just drawn what he saw in the photo, neglecting to work out the perspective and making sure it was correct.

It's fine to use a photo as a reference, but you still have to use what you have seen in the real world. The best way to combat being a slave to your reference is to do a butt load of life drawing. When it comes to reference, the best one will always be life drawing. By doing a lot of life drawing, you will be able to build your visual library, which will allow you to fill in the gaps that the camera might miss or distort.

Here are some examples of how you can use reference without being a slave to them. The idea is to use what you need and be creative with the rest. For example, here is a headshot of me screaming.

I was able to use this image as a reference in a comic sequence. The following two panels for that sequence show the same guy screaming, but you can see that I used only what I needed and then created what wasn't there—for example, turning the head in the second panel. If you take a look at the two images below, you will notice that the images are similar but not a copy of the photo. Using the general mouth shape and the wrinkles coming from the nose, I further push the expression of the characters.

Here is another example of me in a more action-oriented pose and the final image I used for a card for the TCG *Dark Legacy*.

In the next example, I am posing for a character illustration. Notice how the pose is similar but not exactly the same. The character pose needed both arms to be straight out, but I have to say that gun was pretty heavy!

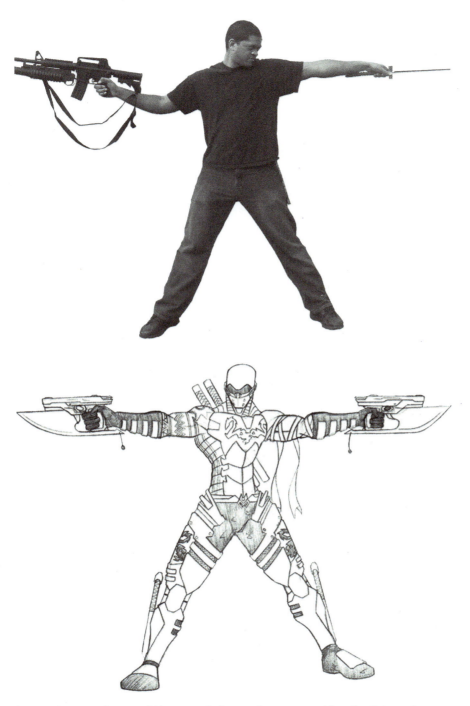

Is this starting to make sense? I hope so. Reference is a great tool for all artists, and you shouldn't be afraid of it. Just make sure that the final product is your own creation and don't be a slave to your reference.

PRO TIP!

There is no excuse not to use reference for anything, especially nowadays. Don't trace it or copy it, but use it to inform what you're doing at all times.

—David Silva

Another type of reference that people use all the time but don't know they are using is research. I'm not talking about the kinds of references you use when you write a term paper and cite your sources. I mean the research you need to do for a specific character. Let's say you have a character who is based in the 1940s. You would have to research the fashions, the cars, the buildings, and so on, of that era. It might sound like an awful lot of work for just one character, but it is incumbent upon you to produce something that is absolutely authentic. And the only way you can do that is with research.

The same thing holds true when you draw characters with special abilities. For instance, if your character is a parkour specialist,

then you would have to research how a person who has mastered parkour moves. You could go to a studio that teaches parkour and do a bunch of life drawings, but we already talked about the problem of people in motion. So it would be a lot easier to go online and look at videos and photos of people performing parkour, right?

Got it… research to make sure everything works together!

There is one final type of reference I want to discuss. This type of reference is often not considered a true reference at all. I understand why, but I think that it is another strong type of reference. It's *inspiration*. You are probably thinking something like this:

Why would what inspires me be reference?

Well, in my humble opinion—and this is only an opinion—when artists are looking for good references, they often get lost in the cool stuff, especially on Pinterest. I don't know about you, but for me, when I am looking for reference and get sidetracked by the cool stuff, it tends to be other artist's drawings, paintings, movies, animations, toys, comics, and so on, but again, you can't be a victim to your references. If you draw your own character based solely on another artist's work, you are assuming that they did all the necessary research and that their drawings are correct. This comes under the category of DTA: *don't trust anyone*. In our case, it stands for *don't trust artists*. You never want to assume that the other artist did all the work he or she should have. When you do your own research, you *know* it is right.

Have you ever found an image on a poster or online that inspired you to start drawing something similar? I know I have. When I attended the San Diego Comic Convention, I saw a mural for Marvel comics with a drawing of a female Viking. (I think it was supposed to be a female Thor.) It looked so awesome that I took a picture of it. When I got back to my hotel room, I printed out a couple of images of Vikings from the computer. It turns out that Vikings didn't have horns on their helmets. (It had something to do with sailing and rigging and stuff getting caught on the horns.) Who knew? In this instance, the artist was going for a cool aesthetic. What is aesthetic? you ask. Well, that is something that we are going to get into in Chapter 7. Sometime you will sacrifice what is correct for what looks cool, but like I said, we will get into that in detail in the next chapter.

So as you can see, it happens to everyone. You have to remember that just because it looks cool, it doesn't mean it is correct. That is why I went back to the hotel and printed my own Viking reference, and for three other reasons. One, I needed more Viking reference. Two, I wanted to make sure that the inspirational image was correct. Three, I didn't want to be a slave to the inspirational reference image.

I hope that after reading this chapter you are now convinced that reference is a very useful and powerful tool to have at your fingertips and it isn't just a way for artists to cheat. Now, I need you to say this with me, "*Reference is not cheating!*" Just make sure you don't fall victim to the reference and become a slave to it. Get it? Got it? Good!

Homework Time!

It's homework time! This time, I want you to make two different drawings of the same character: a sheriff in the Wild West. One drawing should just be from the top of your head, using no reference at all. For the other one, I want you to use all the types of references discussed in this chapter. Afterward, compare the drawings and see if there are any differences. Have fun and I'll see you in the next chapter.

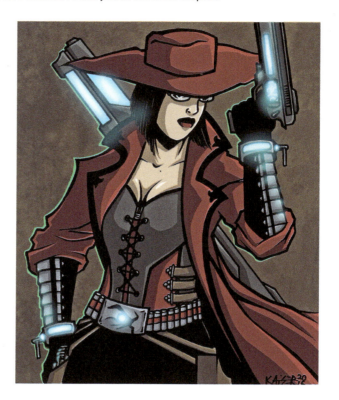

Aesthetics—Just What You've Been Waiting For

How did your assignment go? Did you notice anything in particular about your drawings? Did the image that you used reference for look more authentic than the one that you created from off the top of your head? I hope it has encouraged you to use reference a lot more. I am not going to waste any more time. We are going to jump right into aesthetics. I know we discussed aesthetics briefly when we talked about shapes, but that was mostly about structure. Now we are going to get to the meat and potatoes.

Aesthetics is defined as "the philosophy dealing with the nature of beauty, art, and taste." Hopefully, you can understand why all these are important to character design. The aesthetic is the first thing the viewer will notice about your character design. No matter what anyone wants to tell you, human beings are attracted to things that look visually appealing. (That's why it's called love at first sight.)

Oh come on, you know it's true, and it is no different with character designs. When they see an attractive character, people want to know more about it.

With that said, there is no cookie-cutter formula that will always make your character appealing to everyone on the planet. People's tastes vary widely, and there is something out there for everyone. You just have to find it. So how can you get the most bang for your buck when it comes to the aesthetics of your characters?

The first thing you have to think about is your audience. If you are creating the character only for yourself, then all you have to worry about is what *you* like. But if you are trying to reach other people, you have to consider the preferences of the other people who will see your character design. You have to answer two important questions:

1. What is the age group that you are aiming for with your character design?
2. What genre is your character going to be in?

These are the two most important considerations because the aesthetics of your character design depend on your answers.

Let's talk about the age factor first. You will have to do some research to see what the target age group is watching, playing, and reading. This is called "knowing your target audience." Do you know what 0- to 4-year-olds are watching on TV or the Internet? Do you know why they aren't watching the same programs as 5- to 8-year-olds or 14- to 18+-year-olds? You might think you know, but do you really know? Before you answer that question, I'll tell you what I think about the different age groups, and we'll see if you had the same ideas.

I am going to break down the age groups as follows. (This may vary from person to person, but this is generally what I go by.)

> **Ages 0–4** Characters have really big heads and eyes, short bodies, bright colors, and simple shapes.
> **Ages 5–8** Characters still have big heads but less so than characters for the 0–4 age group. Their eyes are smaller, the colors are a bit more muted, and the shapes are more intricate.

Ages 9–13 Characters are pulling away from the simplistic. They resemble more believable proportions. The colors are more realistic and have a lot more details.

Ages 14–18+ Characters resemble the real world. They are properly proportioned. The colors are more complicated, and they have the most amount of detail.

Why is this important and why should you care? It's important because it directly influences the design. You don't want to give the viewers too much information if they can't process it. For example, look at what a 4-year-old is watching and then look at what a 14-year-old is watching. Do you notice that the 14-year-old's program has a lot more to look at? There is more they have to process. This is because the older you get, the more information your brain can handle and process. I'm sure that there are cases where that isn't true, but that is the general rule.

PRO TIP!

I absolutely recommend keeping your audience in mind when designing characters. Designs aimed at young children work best when they're simple and brightly colored. Keep the intricate details and features for older audiences.

—Robyn Williams

Another reason you really want to know your target audience is because you don't want to market a character to the wrong age group. Imagine being the artist who has this great idea about a bloodthirsty mercenary who specializes in killing demons and monsters, and his main quest is to hunt down and kill the devil.

It's graphic, gory, and violent, and it even has a little sex in it. Then somebody asks you what age group you plan on marketing this character to, and you reply, "I was thinking 5- to 8-year-olds." Would you let your 5-year-old watch something like this? I know I wouldn't. So you want to make sure that your character is going to fit in with the age group you have in mind.

Since we are all visual people, I am going to give you examples of characters placed in the different age groups. First, we are going to look at a character in the 0- to 4-year-old group.

As you can see, this character is very simplistic. There isn't a lot of information to process, just the basics. If we break this character down, you will see that the character is only two heads tall, with the largest part of the character being its head. The idea behind the big head and big eyes is to make the character cute and less threatening. Also, if you look at the lines that were used to define the character, they are very minimalistic. Finally, notice that the colors are very basic—basic in the sense that they are all part of the basic color wheel. There are no highlights or tints to any of the colors here. As character designers, we would choose these colors because they are what the age group is learning about.

If you don't believe me, I'll tell you that as a newly minted father, I can tell you out of experience that when my child and I are discussing colors, we stick to red, blue, yellow, and so on. Even though I am an artist, I wouldn't tell my 2-year-old that the color isn't really red but burgundy. That will come later if he develops an interest in art.

Which brings us to the 5- to 8-year-old group.

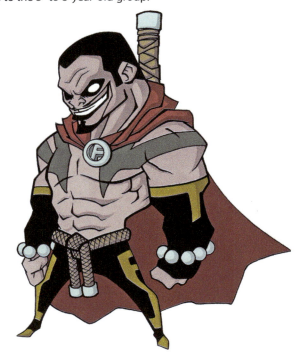

As you can see, the character design has changed a bit. Not by leaps and bounds, but enough to be noticeable. Let's break it down. The head size has become a bit more realistic. Although the character still has a big head compared to the body, it's about three heads high. The line that defines the character is still pretty minimal. The details have become a bit more evident. So we get to see a few more things that define who the character is. The colors are also a bit more advanced and require more of an understanding of color theory. We are getting deeper into what and who the character is.

Now we'll look at the 9- to 13-year-old group. Everything changes in this age group. Kids this age are finding out about the world around them, and they are curious about everything. At this point, they should have the mental capacity to understand and comprehend what is put in front of them. So let's see what a character would look like in this age group.

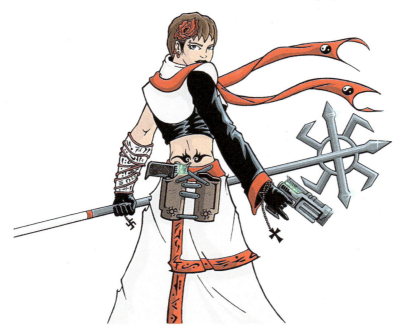

Do you see how the design has changed to accommodate a more mature level? The line detail and color have become more sophisticated. This is because most artists designing for this age group understand that these kids are well on their way to becoming adults. And you can bet your bottom dollar that this age group doesn't want to be treated like kids anymore. Some of you might be thinking:

At nine, I didn't want to be treated like an adult.

I'm afraid I have to disagree with you. How many 9- to 13-year-olds have you heard say, "I'm not a kid anymore?" I never said they *were* adults, just that they didn't want to be kids

anymore. With that in mind, it is fairly easy to design for this age group because you can design stuff the same as you would for the 14- to 18+-year-olds. Here, let me show you.

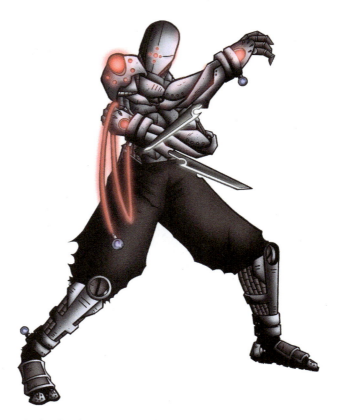

Do you see how similar the designs are? At this age people have a fairly decent grasp on what is going on around them. So they want what they are looking at, whether it is fantasy, sci-fi, horror, or whatever, to be rooted in reality as much as possible. There are always exceptions, but as a general rule, you can count on this being true. At this point in life, people are able to take on more information. Therefore, a lot of designers will have a lot more moving parts in their designs. Because this age group can process more and more information, it is key at this point to make sure that your designs follow the *form follows function* rule, because if you don't, your audience is going to pick up on it and it will ruin the experience for them and make them disinterested in your characters as well as your story.

So the most important piece of information to obtain from this discussion is that every age group wants to be able to relate to what they are looking at, and as designers one of the big things to relate to is the way a character looks. That is why the younger ages are modeled with childlike proportions and the older age groups want something more adult.

Now, let's talk briefly about genre. The thing you have to remember is that each genre has very specific qualities that fans of that specific genre want to see every time. So if you are going to be doing a fantasy story, your characters must have some mystical qualities about them. They probably also have to fight dragons, orcs, and goblins. If you are doing a Western story, your characters have to be willing to get on a horse and wear a cowboy hat. Once again, there are always going to be exceptions, but genres are based off generalizations. Within these generalizations is where character designers live, but remember, as we discussed in Chapter 2, the issue when relying on stereotypes is that one can fall into lazy character design. Designers will tend to use oversimplified character types, and thus the characters start to show a lack of originality and diversity. So make sure you know the subject matter of the genre in which you are going to place your characters.

Another thing to keep in mind when thinking about genre is that you are going to need to do some research on the genre itself. Now you might take what you learned from your research and completely fantasize it up, but knowing the details of that genre will benefit your story greatly. For example, people love to create characters from the postapocalyptic genre. Most designers won't do any research on war-torn countries or third world countries to see what life would be like in that kind of situation. A great example of that is how women are portrayed in postapocalyptical situations. In most fantasy or sci-fi postapocalyptical stories, the women all, primarily, are well groomed, and clothes are in perfect condition and look amazing. This just wouldn't be the case. Think about it, the life that everyone knows would be gone. Shaving one's underarms or legs wouldn't be on anyone's top priority list when your life is in jeopardy every single day. If you consider these kinds of details, not only will your character have a richer story, but so will the overall story.

This ties in with research and Chapter 6.

As we continue to look at aesthetics, one of the most important features is color. Color says a lot about a character and his story. It also affects whether a person will have a connection to a certain character. People tend to gravitate toward other people who like the same things they do. Color is one of the things that people tend to gravitate to; it is a mnemonic device that easily works, which you will see later. So it is very important to know the meanings of the colors you use.

First things first; we have to look at the basic color wheel, and then I will convince you that color tells a story about your character.

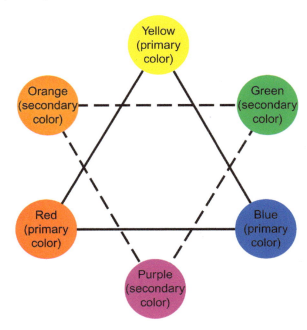

The color wheel shows the primary, secondary, and complementary colors. Complementary colors are directly across from each other, so red is the complementary color of green, and blue is the complementary color of orange, and so on. I'm telling you this because, well, it isn't labeled on the color wheel and I didn't want you to be confused about what complementary colors are. If you are ever confused about what colors complement each other, think about this: graphic design and marketing firms use complementary colors all the time in their designs, marketing, and advertising. Don't believe me? Think about this. What colors are primarily used for Christmas? *red* and *green* … complementary colors. Need another example? What colors are primarily used for Easter? *purple* and *yellow* … complementary colors. Lastly, nature uses the complementary colors of *blue* and *orange* with the sky and sun. Now that you know three examples, you shouldn't have any problems with complementary colors anymore. Now here are the colors that we are going to be looking at in depth:

Red
Yellow
Blue
Purple
Green
Orange
Black
White

Basically, we are going to talk about the color wheel plus black and white. I know there are many more colors in our world, but these are the main colors that we as character designers use.

The first thing we have to do is find out what each color says to people.

The color red generally evokes feelings of *action, confidence, courage, vitality, energy, war, danger, strength, power, determination, passion, desire, anger,* and *love*.

The color yellow generally evokes feelings of *wisdom, joy, happiness, intellect, caution, decay, sickness, jealousy, cowardliness, comfort, liveliness, optimism,* and *feeling overwhelmed*.

The color blue generally evokes feelings of *trust, loyalty, wisdom, confidence, intelligence, faith, truth, health, healing, tranquility, understanding, softness, knowledge, power, integrity, seriousness, honor, coldness,* and *sadness*.

The color purple generally evokes feelings of *power, nobility, elegance, sophistication, artificial luxury, mystery, royalty, magic, ambition, wealth, extravagance, wisdom, dignity, independence,* and *creativity.*

The color green generally evokes feelings of *nature, growth, harmony, freshness, fertility, safety, money, durability, luxury, optimism, well-bein*g, *relaxation, optimism, honesty, envy, youth,* and *sickness.*

The color orange generally evokes feelings of *cheerfulness, enthusiasm, creativity, fascination, happiness, determination, attraction, success, encouragement, prestige, illumination,* and *wisdom.*

The color black generally evokes the feelings of *power, elegance, formality, death, evil, mystery, fear, grief, sophistication, strength, depression,* and *mourning.*

The color white generally evokes the feelings of *cleanliness, purity, newness, virginity, peace, innocence, simplicity, sterility, light, goodness,* and *perfection.*

So as you can see, there are many different feelings associated with each color. At this point, you might be asking yourself this question:

How can there be so many different feelings envoked by one color?

Each color has many tints and shades, and that is where the different feelings come from.

Notice how a different tint or shade applied to the base color changes what the color is saying about itself. The darker red conveys more anger and rage, whereas the lighter red conveys a softer, loving side. I will show you a couple other colors and you will see that just by changing the tint or shade of the base color, a different emotion will be evoked, and this is something that you as a character designer need to understand and use to your advantage.

Something that you also have to remember is that unless you are truly working with only flat and singular colors, you have to think about the colors that you use in conjunction with your primary colors. Using complementary colors is a huge help with choosing the colors to accompany the primary colors. Being able to choose and properly use colors can make or break your design. Don't believe me? Then check out the example where I use black, white, and a color family color.

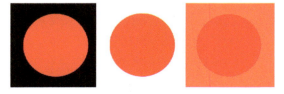

Do you see the differences with these red circles? The red circle that has a black background seems to be almost glowing or radiating off the black background. The red circle with white background seems to be duller and have less energy. Lastly, the red circle with the orange background almost seems lifeless and almost blends into the background. Do you see how certain colors will give you an intense color and the others will dull out the color and make it less interesting? What do you think will happen if you change the color on a character? I bet it will tell a different story about your character. Here is an example.

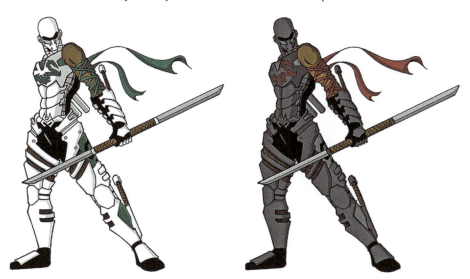

Do you see how keeping the same character but changing the colors creates a completely new character? This example using a character that is predominantly white and one that is predominantly black is pretty obvious, but I guarantee it works with all colors. Here is another example.

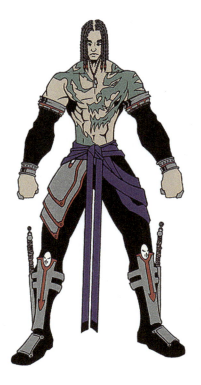
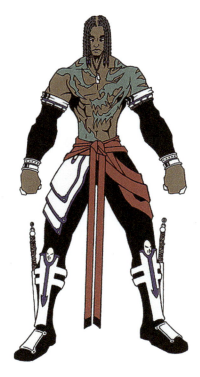

Did you see the difference? Are you getting a sense of the character being a bit different? These two are subtle, but the differences are still there. What do you think about the next two?

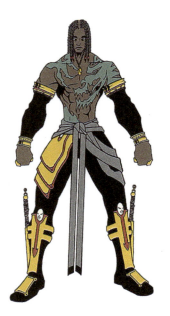 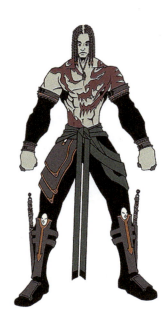

Did the character change? Did his story change? What if you look at all four? Are you starting to see that color has an impact on the story of the character? I have one more set of this character to show you.

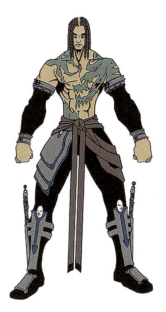 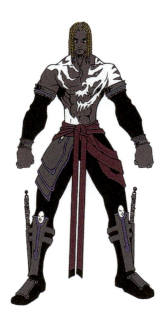

I hope these examples helped you to understand the importance of the colors you choose. If you don't put considerable thought into your colors, you could end up with a character that doesn't match the story. Let's look at how characters like Marvel's Spider-Man and Hasbro's Snake Eyes and Storm Shadow have colors that match their stories.

PRO TIP!

I spend a lot of time looking for a color scheme that tells me something about the character, and also highlights what elements of his design are the most important.

—Enrique Rivera

With Spider-Man, the predominant colors are red and blue. If you look at the colors and the feelings they evoke, you should be able to place some of them on Spider-Man's character. If not, I am going to break it down for you. Remember that we said that blue means loyalty, intelligence, sadness, and power; among other things, Spider-Man is very loyal to his family and friends, and most of all to New York City. Spider-Man is intelligent because Peter Parker is proclaimed to be a scientific genius. He has power because of his spider strength, but the big one is sadness. If I were to pick a primary reason as to why they picked blue, I would say it is to represent sadness. Spider-Man's life is constantly overshadowed by the death of his Uncle Ben. He became a crime fighter because he believes his uncle's death was his fault.

Let's talk about red. Red means passion, love, courage, confidence, and energy. Spider-Man is very passionate about what he does. He believes that he can clean up the streets of New York, and let's face it, you have to be pretty passionate to put yourself into the situations he puts himself in. He loves his family and will do anything to keep them safe. Spider-Man has confidence in what he can and can't do. It actually borders on being extremely cocky, but it fits with who he is. Finally, if any character has loads of energy, it would be Spider-Man. He jumps, flips, swings, and fights—everywhere and anywhere.

See how everything comes together so nicely? You might think this is all just coincidence, but even if Steve Ditko, the designer, didn't do it deliberately, it was still in his subconscious.

Before we discuss Storm Shadow and Snake Eyes, I want to tell you that these two came up at a lecture I gave. An audience member asked me why the colors for Storm Shadow and Snake Eyes were reversed, since Storm Shadow is the bad guy and is wearing white, and Snake Eyes, the good guy, is wearing black. I was glad somebody asked that question because I was able to relate it back directly to both of the characters' stories.

If you look at Snake Eyes, you will notice two things: he is supposed to be a ninja, and he is supposed to be a commando in a military special forces unit. So most likely you would wear black for both jobs so you could sneak around undetected, right? Right! That right there would be good enough to suffice for why Snake Eyes wears black. If we were to dig a bit deeper into the character's backstory, however, we would discover another reason why he wears black. Snake Eyes is mourning the death of his ninja master, Hard Master, and as we saw, one of black's meanings is mourning. Now what about Storm Shadow?

We said that white means purity, peace, innocence, goodness, and perfection and is usually associated with the good guy. But when you think about Storm Shadow, these feelings probably don't come to mind. So we have to go back to the character's story to find out why this color is appropriate for him. We learn that Storm Shadow was framed for the death of Hard Master. He devoted much of his life to proving his innocence. Also, Storm Shadow constantly strives for perfection. Finally, Storm Shadow always believes that he is doing the right thing, so he feels his motives are pure.

So there you have it! Color can change everything about your character. Just make sure the colors you choose for your characters are saying what you want them to say. The best way to make sure is to ask other people what they think your character is all about. If it lines up with what you had in mind, great! If it doesn't, it's back to the drawing board.

When it comes to aesthetics, another important thing to keep in mind is detail. Details can be the deciding factor in whether your character design is successful or unsuccessful. Knowing how much detail to put in your character designs will make the difference between

a believable character and one that couldn't possibly exist. There is a saying in the artistic world: the devil is in the details.

What that means is there is a fine line between having too much detail and not having enough. You must always remember that your personal style and the age group of your audience will influence how much detail you need. Even if the age group is in the lowest category, that shouldn't be an excuse to draw unrecognizable and lazy characters or props.

Students often say to me, and I quote, "Oh, that is just my style, and that is why there is a minimal amount of detail." The problem with that statement is that *style* isn't an excuse. Style is how you perceive the world around you and are able to put it on paper, canvas, or computer. If we can't tell the difference between your drawings of a gun and a toaster with a handle, it isn't your style; you just don't know how to draw a gun.

I once had a professor who used to say that L is the most dangerous letter in the alphabet. It's not a style. It's like reference—the more you draw it, the more it will be engraved in your brain and you will be able to call upon it at any time. That's right, I just made reference to Chapter 6 again. Do you see just how important that last chapter was? It just keeps coming up. If you don't remember what we talked about there, go back and read it again. It is all about reference. But seriously, let me show you what I am talking about.

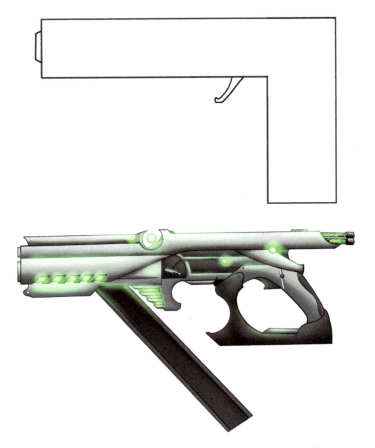

The preceding two drawings can both be classified as guns. We accept them as guns even if one of them is only the letter L with a trigger and the other is a fantasy/sci-fi gun that doesn't exist. But which one do you think is more believable? It won't always be the one that has more details. Depending on your target age group, there must be a balance between realistic and stylistic. Don't get lazy and use the target age group as an excuse to be overly simplistic.

So how much detail is the right amount? The only way to be sure is by trial and error. There is no magic formula. It's a shame, I know, but what are you going do? What I always recommend to my students is that you should show your work to someone who knows nothing about art and your craft. A good person for this is an accountant. Why, you ask?

You probably know that the people in your social circle are only going to give you compliments, and that's not going to help you become a better character designer or artist in general. Thus, somebody who is completely foreign to your craft will at least tell you the truth. The good, the bad, and all the things you didn't want to hear about your beloved masterpiece. Another good person to show your character designs to is someone who doesn't like you. That person will gladly tell you why your work is awful—in excruciating detail—and then it is up to you to take what was said in that verbal bashing and use it to make your designs better.

I am a practitioner of this method of critique. My wife always says she knows nothing about art, so I use her to critique my work. She doesn't hesitate to tell me how awful something is, but, after I swallow my pride, I take a step back, look at my work, and use her remarks to make it better. Believability is the name of the game, and it is very important that it is obtained at all cost. So try this. Show your work to people who will be honest about it. It will make your creations stronger, and that is worth the ego beating.

I know we covered a lot in this chapter, but I hope it's sinking in because it is now time for your homework.

Homework Time!

I want you to finish a full character design in color. Based on the shapes and the colors you used, write about the character's backstory. Once you have done that, show your character design to three other people and see if they get the same story you did. See you in the next chapter. We are getting close to the end. Crazy, huh?

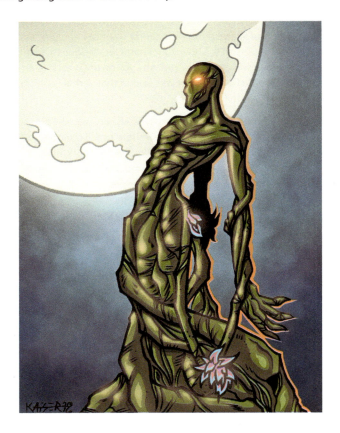

The WOW Factor

How did your homework assignment go? Did you show your work to people you didn't know or didn't particularly like? It's kind of a different experience, isn't it? I hope you will continue to request feedback from people outside your comfort zone. It will make you a better artist in the end. Now let's talk about something that I like to call the WOW factor.

The WOW factor is something every character designer and artist tries to achieve. For years I have emphasized to my students that the WOW factor will put their art on a pedestal. Often, however, like with originality, people try way too hard to achieve the WOW factor.

So, what is the WOW factor?

I'm glad you asked! The WOW factor is that one thing about your character design that stops people in their tracks when they see it and makes them say, "WOW, now that's cool!"

Can you think of any popular character designs that evoke that kind of response from you? What particular aspect of the design made you feel that way?

Most likely, it had something to do with the colors, the silhouette, the aesthetics, or something that you just thought was cool. These are all good reasons, and I want you to think about it for a few minutes. Think about some of the features we covered in this book and decide if any of them would make *you* say, "WOW, now that's cool!"

Do you think you would feel this way no matter what character design had this particular feature? Before you say, "Of course," I should tell you that in my experience only a very small percentage would benefit from a different character's WOW factor. Do you know why that is?

I hope you're not going to be like a lot of my students and just wait until I give you the answer. Fine. Normally, taking a different character's WOW factor and adding it to yours doesn't work because each character was created with a unique design in mind. Once you start adding someone else's vision of a character to your character design, it doesn't feel like your design anymore—unless you don't have your story finished!

Before I go on, you do have your character's story finalized, don't you? Please tell me you finished your story. You shouldn't even be thinking about the WOW factor until you know exactly what your story is. If you haven't finished your story, you need to go back to Chapter 3 and finish it. You can come back after that is done. Don't worry, I won't go anywhere. I'll wait.

You're still here? I guess your character's story *is* finished. You have to understand that this is the icing on the cake. You can't expect people to be happy with just the icing. (I suppose there are people, like my son, who are perfectly content to eat just the icing, but after the sugar crash, they'll be looking for the cake.)

We are still trying to figure out why one person's WOW factor isn't good for another character. Let's use some popular characters as examples.

If we were to give Spider-Man the Batmobile, would that make Spider-Man a stronger character design? Would Superman's character design look better if he carried a He-Man sword? Would Hordak be any more bad@#$ if he were wearing Cobra Commander's helmet? I am sure some of you are thinking:

Well, as cool as it might seem, the problem is that these characters already have a strong story, and the minute you start adding someone else's story, it breaks the consistency that has already been established.

I have had students show me comics, movies, cartoons, and games where the creators have done what I just told you not to do. What my students fail to realize, however, is that what they are showing me appears only in one issue or episode. The only time it might be used for subsequent issues or episodes is when the creators have a very specific storyline planned for the character. Whether it is one issue or a full storyline, in the end both characters' stories go their separate ways, and with that separation the WOW factor would go back to its rightful owner.

So it's not necessarily a good idea to use someone else's story. Let's just say it plainly: the WOW factor is the ability to make a character design so appealing that it will pull people right out of a conversation they're in the middle of. Has that ever happened it you? It's happened to me—usually when I am watching trailers for upcoming movies. I find myself asking:

It generally boils down to a good story that was executed well within the character design. Sometimes it deals with aesthetics, and we all know that aesthetics is dictated by the story of the character design.

Once the movie is over, and I am done being entertained and inspired by other people's character designs, I go to the drawing board. I try to create characters that would be just as inspiring to others, like the way the ones in the trailers were for me. After a while, I come up with characters like this:

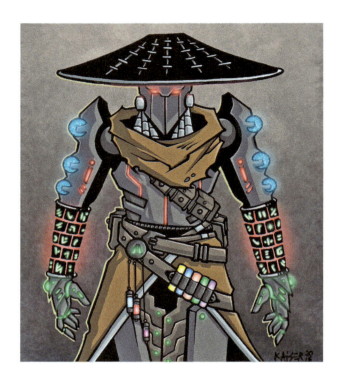

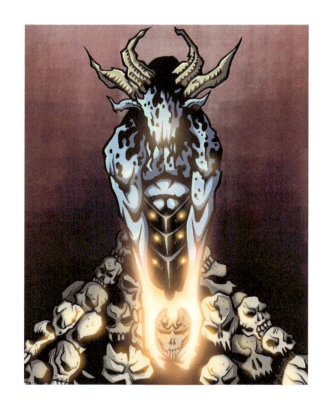

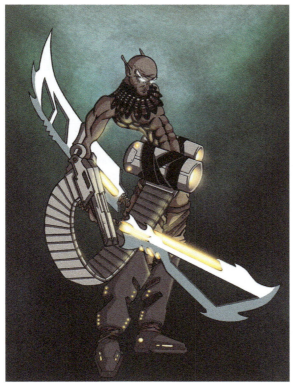

While I am creating these characters, I try to keep one thing in mind: Will a kid get his butt kicked if he is wearing the costume that my character is wearing?

You might laugh, but this is a very important question to ask yourself. Little kids can be downright mean, and you don't want them to beat up the kid who is wearing your character's costume, do you? You wouldn't want that on your conscience. In all seriousness, you want to think about your fan base. You want to make sure that your characters will look cool if people cosplay as them at a convention. For instance, seeing a grown man wearing a Robin costume just isn't cool at all.

Another good way to try and create the WOW factor for your character designs is to think about contrast. I don't mean contrast in the sense of color, but you might be able to make that work if the story allows for you to do that. I am talking about contrast in story. For instance, I want you to imagine a really rough-and-tumble biker. One that happens to be a burly man with a scruffy beard, full-body tattoos, angry eyes, leather biker vest with snakes and skulls on it, and then you see the cutest little fluffy white kitten in the left breast pocket of the vest. Can you visualize that?

If you are like most people, you will be intrigued by the fact that this hard-core biker would be toting around and protecting this little kitten. Why is he doing that? Is there a reason for it? There are so many questions that you would be asking yourself; all the while you would be staring at the character trying desperately to find any other clues that might be present on the biker to answer all of your questions. This is a great example of a WOW factor element in a character design.

Another good example of contrast can actually happen within the story. For example, think of your stereotypical librarian. You know, the shy, quiet, meek, reserved, and generally weak. Now think about the stereotypical librarian outfit, midcalf skirt, kitten heels, blouse with a ruffled collar, hair in a bun, and big glasses that are hanging from a black beaded necklace. Do you have the visual of this librarian? Good! Now what you need to know is that this librarian is the UFC's women's champion. Now think about that visual. You see the librarian in full librarian outfit wearing the UFC gold around her waist. You would instantly stop and wonder what this character is all about. How is this possible? She has to be a bad@$%! That is a great example about contrast within the story to provide a WOW factor element.

PRO TIP!

Also, don't overcomplicate the design if the character doesn't require it; a character can look cool without being overly detailed to the point where you lose their personality.

—Elvin Hernandez

There is one last thing that you can do to obtain the WOW factor, and that's making your character as awesome as possible. I know I have already given you a bunch of rules and guidelines to follow. But if you really want to obtain the WOW factor, you are allowed to break one of them. You only get one, though, because when somebody asks you, "Why did you do that?" you can only say, "Because it's awesome!" once before people start to question the solidarity of your character. So don't make it a point to break the rules, but if something in your story breaks the rules, it's forgivable.

Make sure that last part is ingrained in your memory: If your *story* breaks the rules, then and only then is it forgivable—once. So when you create a character like this

you have to be prepared with a believable story to explain how the character has huge metallic wings coming out of his back. The reason why you will have to be able to explain why it is awesome is because a character that has metal wings coming out of its back breaks the *form follows function* rule. As I mentioned, you can break a character design rule once and only once, so make sure you remember that.

PRO TIP!

Whether with facial expression or gesture or pose or costume design or accessories or silhouette, try to sell as much fresh intrigue as possible in one character.

—Scott Prescott

I hope you now understand what the WOW factor is and how you can achieve it for your own character designs. Now, I don't know if you have noticed the underlying theme that has been running throughout this chapter; well, to be honest it has been the main theme of this entire book, but the WOW factor is completely based on that theme. Any guesses? That's right, you guessed it:

Story Is Everything!

Now that you know the true secret behind the WOW factor it is time to make sure you actually understand it, and the best way to make sure you do understand it is to try it out yourself.

Homework Time!

Your homework is to design a character that has the WOW factor. Once again, you have to show it to a couple of people and observe their reaction. Only then will you know if your character really has the WOW factor. Good luck!

I will see you in the next chapter—the last one!

Putting It All Together

Hello again and welcome to the last chapter. Did you do your homework? Were you able to achieve the WOW factor with your character? If you spent all your time trying to figure out how to give your character the WOW factor, I bet you had a really hard time finishing your character. If you let the story guide you to the WOW factor, I am sure you didn't even have to try. It just came out, didn't it? I hope you understand how powerful the WOW factor can be. I have a feeling that you might be thinking this:

What can there possibly be left to talk about?

I know how you feel. We talked about a lot of things in this book. We talked about archetypes, story, shapes, silhouettes, colors, details, age groups, originality, references, and the WOW factor. What's left to talk about in character design? There is a lot more that we could talk about on the subject of making a stronger character design, but I think that is for another book. What I want to talk about in this chapter is putting it all together.

By now you should have a good understanding of what is required to make strong character designs. But what do you do with them once you have them? There are a couple of things you'll have to know how to do once you become a full-time character designer.

As a full-time character designer, it isn't enough to be able to create fantastic character designs. You will also have to be able to turn them in space. This is known as a *turnaround*. Many media arts companies use turnarounds to ensure that when you draw the character you know what it looks like from the front, the side, and the back. These turnarounds are also very helpful for 3D artists who would have to model the characters that you have created. It is very important that when doing these turnarounds you keep in mind that as the character turns in space, you will need to make sure that everything lines up. If everything lines up, it makes it easier to model without having to do a lot of corrections on the anatomy and proportions. As mentioned at the beginning of the book, this isn't a how-to-draw book, but I feel that it is very important that you know that proportions and anatomy are very important when doing turnarounds. There are three types of turnarounds: three-point, T, and five-point. I would say that the three-point turnaround is the industry standard for video games, animation, and comics, so why don't we start with that? Here are some examples of a three-point turnaround.

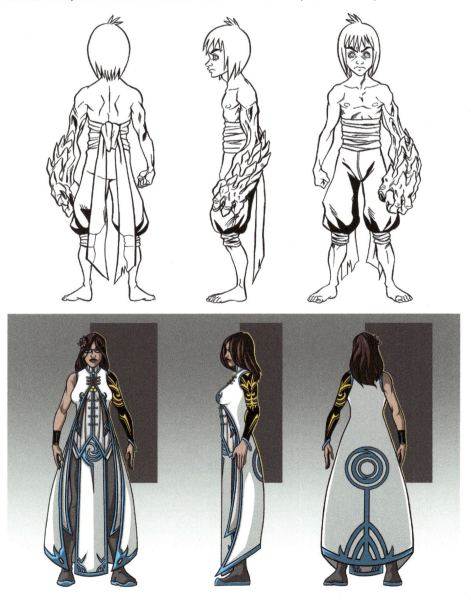

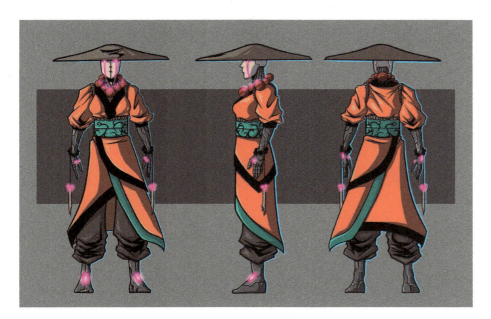

As you can see, having a three-point turnaround at your disposal is very helpful. You don't have to try to guess what the back of your character looks like because there it is.

You might have seen three-point turnarounds that look a bit different from these. In some cases, the arm might be missing from the side view. Some character designers believe that not having the arm lets you see the side of the character better. I don't agree. If you really need to see the side, you can pull the arm back so that you can see both the arm and the side.

You can also use what is called a three-point T turn. This is frequently used by the video game industry because it makes it easier to model in 3D. The reason for that is because when modeling one must be able to see the whole figure in three dimensions, and having the arms up makes it easier to see the connections of all the limbs. Not to mention that being able to rig a character for animation is a lot easier in a pose like this. Here is an example of a T turn.

The final type of turnaround is the five-point turnaround, and it is the most informative. The five-point turnaround is more difficult to draw because of the ¾ front and the ¾ back pose. They are hard to get correct, but once you do, you will have a better idea of how your character turns in space. Here are some examples of a five-point turnaround.

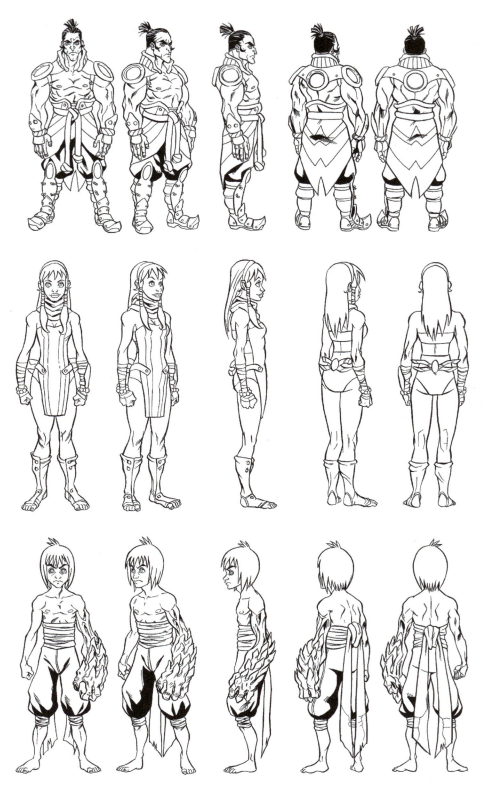

The five-point turnaround is primarily used in animation studios, where it is important to know exactly what the character will look like in all positions. In animation, characters are often seen from several angles. The five-point turnaround is important with asymmetrical characters like the demon-armed boy. His left side doesn't look exactly the same as his right side.

Once you have a strong five-point turnaround, you should be able to draw your character in an array of different poses. These poses are called action poses, but don't let the name confuse you. Just because it says "action" doesn't mean your character has to be punching and kicking (although let's face it, we all want to draw our characters doing stuff like that). They could be sitting, sleeping, waiting for the bus, watching TV, and so on. Here are some action poses of the characters in the preceding turnarounds, and as I mentioned earlier, we all like to draw them punching and kicking, so here are some genuine action poses.

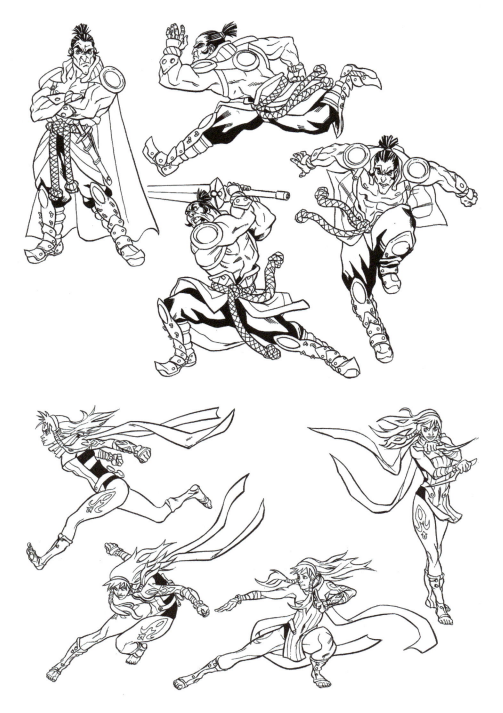

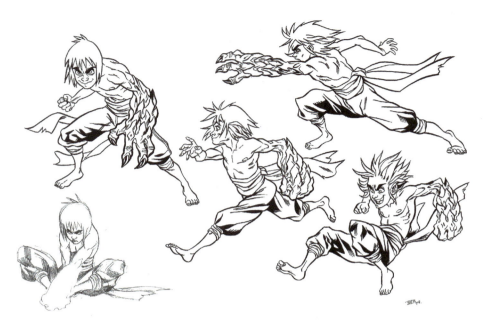

Another thing you want to do is make sure the character's face stays consistent. By drawing facial expressions, you will be able to do just that. It might seem like an easy thing to do, but making sure everything stays the same is a lot harder than you might think. Facial expressions also help us to get to know the visual moods of the character. Here are some examples.

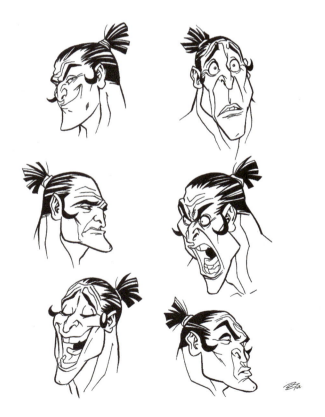

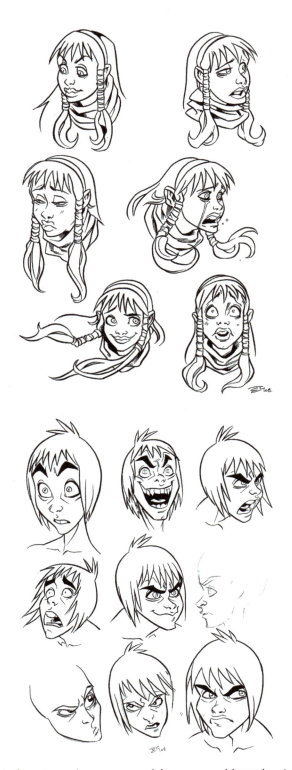

Once you have this down to a science, you won't have any problems drawing your character over and over again. The only problem with that is, at some point you might have to show somebody else how to draw your character. There are two ways to supply enough information about your characters so that others can draw them even if you aren't around. The two ways are with either a model sheet or a style sheet.

I want to start with the model sheet. A model sheet is a combination of the turnaround, facial expressions, head turns, action poses, and descriptions of anything about the character's appearance that is important for every artist to know. Now, not all the things listed will be on a model sheet. The character designer gets to pick and choose what is most important for the other artists. Sometimes the character designer will make two or three model sheets for each character. This is where you would have control of how much needs to be done. Just remember that if you don't give them the information about the super-secret laser earrings, then no one will know about them and they won't draw them on the character. Here are some examples of different model sheets.

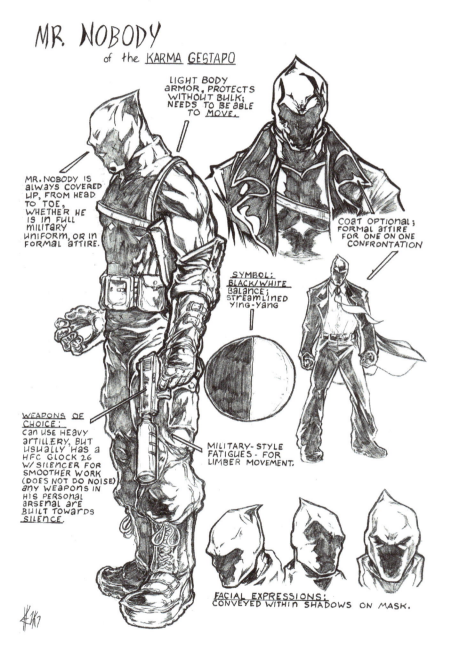

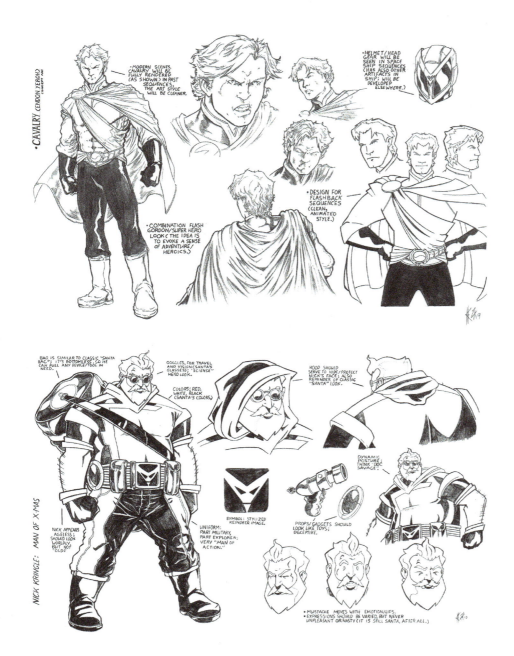

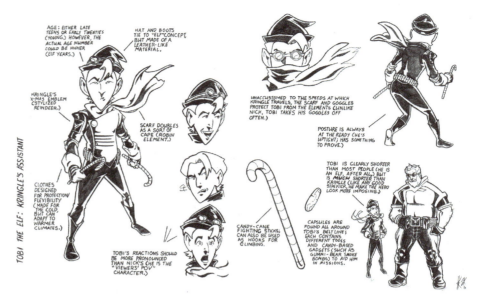

Style sheets are a bit different from model sheets. A style sheet breaks the character down to its most simplistic form so that other artists know exactly how tall a character is, what shape a character is based on, where the nose goes in relation to the eyes, and so on. It's like a blueprint for building a house. With a style sheet there should be no reason whatsoever why another artist shouldn't be able to draw your character and stay on model. What that means is that the drawing from a different artist should look the same as the character designer's drawing. Style sheets are used very heavily in animation. Here are some examples of style sheets.

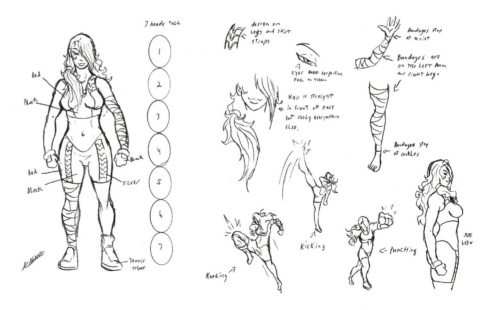

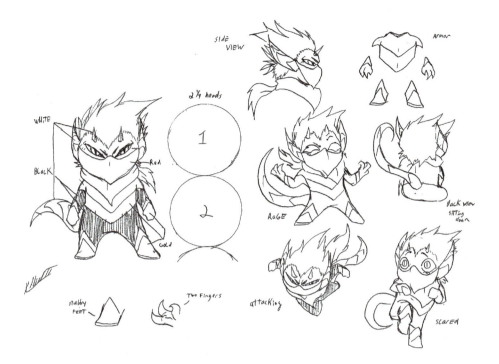

Once you have all this information at your fingertips, your characters will always be able to stay on model, whether it is for comics, animation, illustration, or video games. There is only one other thing that must be done to make sure you and other artists know what your character is all about. That is to make sure your *story* is on point. I know we already talked about this in Chapter 3, and let's be honest, throughout the whole book, but I want to make sure you understand that story is and forever will be the most important part of character design. It always comes back to the story!

To test the idea of story and its importance to character design, I asked some friends— ranging from animation professors, to comic pencilers, to animators, and finally to students—to do two drawings. The drawings were based off the same character. I gave them two different descriptions: one with the absolute minimum amount of story possible and one that was a detailed description of the character. I gave them the minimum description first so that it wouldn't influence the other design. The assignment was to draw a 35-year-old male superhero. This is what they came up with from the minimum description.

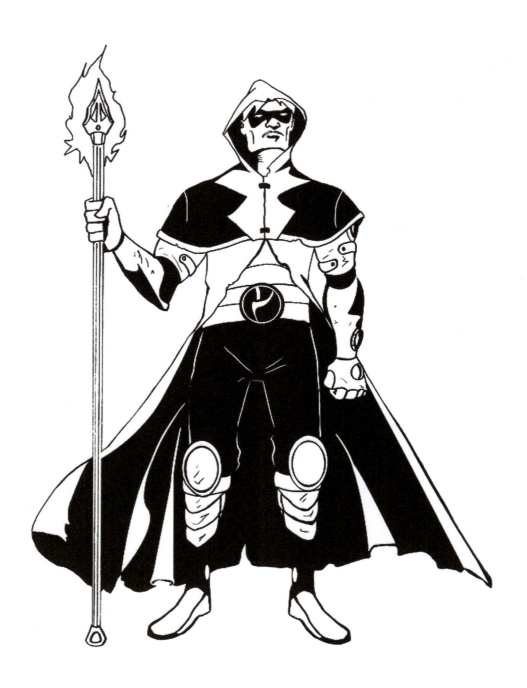

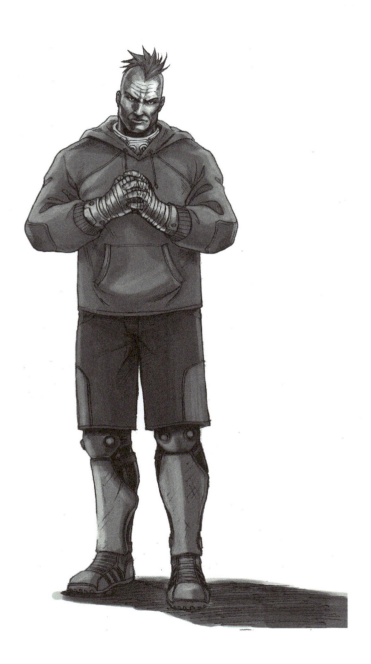

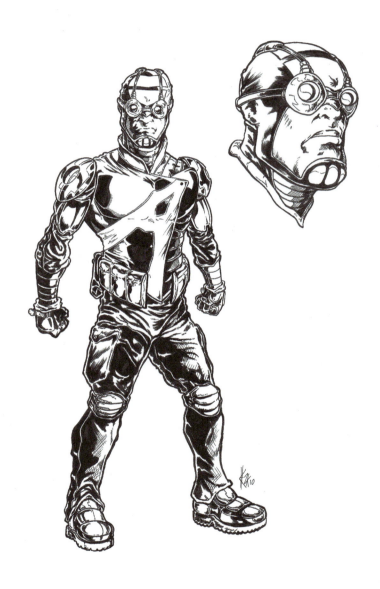

As you can see, there is quite a wide array of characters. That isn't a problem unless you are trying to get a specific look for your character, which most character designers are.

Once they were all done with the first drawing, I gave all the artists the more fleshed-out description for the Golden Grasshopper. This is what I gave them.

Basic Statistics

Name:

Chuck Johnson

Alias:

The Golden Grasshopper

Age:

35 years old

Height:

6 feet tall

Weight:

197 pounds

Sex:

Male

Race:

Caucasian

Eye Color:

Baby blue

Hair Color:

Brown hair cut into a military style

Glasses or Contact Lenses:

Neither

Nationality:

American

Skin Color:

California tan

Shape of Face:

A hero's face. Square jaw with a butt chin; always clean shaven.

Distinguishing Features

Clothing:

Chuck is meticulous about his clothes. His military background doesn't allow him to let himself go. He is always in khaki pants and a button-down shirt.

As the Golden Grasshopper, he wears the traditional military boots with long brown pants. He wears a black short-sleeve t-shirt. He has a golden chest plate, golden forearm bracelets, and a golden half mask that resembles a grasshopper's head. He also wears black gloves so that his identity can't be lifted from his fingerprints.

Mannerisms:

The most memorable mannerism Chuck Johnson has is that he cracks his neck often as a result of an injury sustained during a secret military mission.

Habits:

Chuck has no bad habits. He is the ideal person.

Health:

Now that he is cured from whatever the biological weapon was doing to him, he is back to perfect health.

Hobbies:

Chuck loves to play chess. He is always trying to stay two steps ahead of his opponent. Chuck also loves all music. Music puts his mind at ease.

Favorite Sayings:

"Holy crap! I didn't know I could do that, too."

Voice:

As Chuck Johnson, his voice is subtle and well mannered.

As the Golden Grasshopper, his voice is deep and mysterious.

Walking Style:

He walks very heroically, with his head up and chest out.

Disabilities:

He has mutated blood that is affected by the sun.

Character's Greatest Flaw:

Chuck believes that he isn't doing enough to help humanity.

Character's Best Quality:

Chuck's best quality is that he values life over all other things.

Social Characteristics

Hometown:

San Diego, California

Current Residence:

Savannah, Georgia

Occupation:

Superhero

Income:

Since the government funds the Golden Grasshopper, he is able to afford anything he wants.

Talents/Skills:

Except for the skills he received in the military, Chuck doesn't have any other special skills or talents.

Family Status:

Chuck is a family man. Both of his parents are still alive. They have a great relationship. They are unaware that Chuck is the Golden Grasshopper.

Chuck also has a younger sister with whom he is very close. He has been helping her since her husband walked out on her and their 6-month-old baby. She also doesn't know that he is the Golden Grasshopper.

Character Status as a Child:

He was just an ordinary kid who was the older brother to his sister.

Character Status as an Adult:

As an adult, Chuck Johnson is the Golden Grasshopper, the protector of justice.

Attributes and Attitudes

Educational Background:

Chuck finished high school.

Intelligence Level:

Chuck's IQ is 109. He is an average man.

Character's Goals in Life:

His short-term goal is to figure out what he is capable of doing with his new powers.

His long-term goal is to uphold justice, stop all evil, and bring peace to all.

How Character Sees Himself/Herself:

Chuck sees himself as a superhero who isn't doing enough with his gifts.

Confidence Level:

Even though he doubts that the amount of good he is doing right now is enough, he is very confident that one day it will be.

Emotions:

Chuck is a very logical man, but in certain life-threatening situations his emotions take over completely.

Emotional Characteristics

Introvert or Extrovert:

Extrovert

How does the character deal with:

- Sadness?
 Chuck deals with his sadness by immersing himself in music.
- Anger?
 Chuck is quick to throw his fists when he gets angry, but it takes a lot to make him angry.
- Conflict?
 Chuck deals with each conflict very logically. He always thinks before he acts.
- Change?
 Chuck thinks change is good. If it wasn't for change, Chuck would be dead now.
- Loss?
 Chuck deals with loss just like most people. He reflects on what he lost and hopefully is able to move on in time.

What would the character like to change about his/her life?

Chuck is completely happy with the way his life is now. The change already happened, so now he has to make the best of the new hand he was dealt, and he plans to make the best of it, not just for him but for everyone.

What motivates the character?

Chuck always wanted to be a superhero. That is why he joined the military. Now that he has superpowers, his main motive is ultimately to create peace for everyone to enjoy.

What frightens the character?

Chuck's biggest fear is failure. Now that he has been granted this gift, he doesn't want to fail all those people who now depend on him to keep them safe.

What makes this character happy?

Knowing that he is making the world a better place puts a smile on his face every day.

Relationships:

Being the family man that he is, Chuck is really good with people. Everyone seems to like him. If there is someone he can't get along with, that generally means that person is evil at heart.

Spirituality

Does the character believe in God?

Chuck believes in God.

How strong is the character's faith?

Chuck's moral compass is directly related to his faith. That is what kept him humble in his time of sickness and the main reason he believes that he has been blessed with these powers.

Is the character ruled by his/her faith?

Chuck is not a religious fanatic. He believes in God and tries his hardest to live by his commands.

How the Character is Involved in the Story

Archetype:

Chuck is without a doubt a hero type.

Environment:

The environment is the main reason why Chuck is the Golden Grasshopper. Without the sun, he would still be sick. The sun is the source of the Golden Grasshopper's power. He is now like a walking solar panel. That is why the government made his armor to act like mini solar panels, so when the sun is less abundant, the Golden Grasshopper won't lose his superpowers.

Timeline

Time Period:

1942

Describe five important events that led up to this character's storyline.

- Chuck Johnston was one of the few soldiers who were inducted into the special military detail. He would be the military's secret weapon against the enemy.
- Chuck was exposed to an experimental biological weapon that was being used by the enemy on a covert special mission. As soon as he came into contact with the weapon, he fell ill and needed to be transported to the hospital.
- Chuck was taken to the hospital, where the doctors worked hard to determine what Chuck had and how to cure it. It was here that Chuck rekindled his passion for comic books. As he read comics, he dreamed of the day that he too could be like one of the superheroes in the comic pages and always be the one to save the day.
- Chuck was told that what he had was incurable and that he only had a few more days to live.
- Chuck made a last request to be taken outside so that he could feel the warmth of the sun before he died. The doctors granted him this request. When the sun's rays hit him, Chuck started to feel strange. He felt different, stronger, and healthier. He felt a surge of energy shoot through his body and was able to get out of his wheelchair. To everyone's amazement, Chuck jumped over 18 feet into the air. Once the doctors were able to get Chuck back into the hospital, they ran more tests and decided it was a medical miracle. Chuck Johnson was completely healed. It was shortly thereafter that Chuck decided to protect and serve as the Golden Grasshopper.

Here are the designs they came up with.

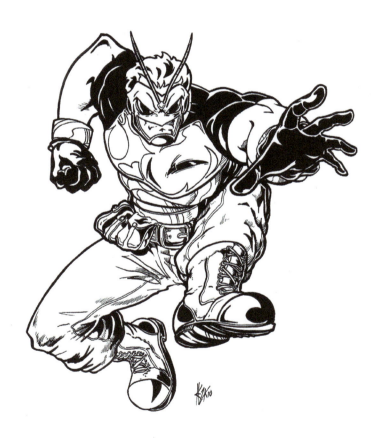

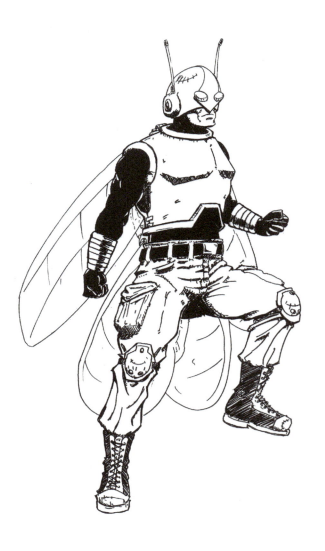

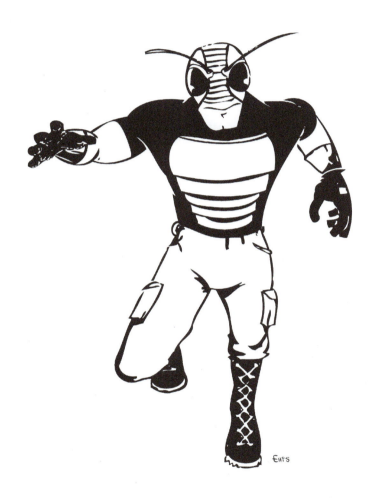

Did you notice that when the artists worked with the simple description they went off in wildly different directions? They were forced to come up with their own stories because with character design, story drives everything, and when left to our own devices, we will pick and choose from what we know. What I am trying to prove here is that with a concrete story, character designers will be able to draw something remarkably close to what the story dictates. You might be saying to yourself right now:

But, they don't look exactly alike.

You know what? They probably never will. Do you want to know why? We talked about it in Chapter 5. Every artist puts his or her own unique twist to the story. They try to add their own form of originality to the character. When they do that, they are trying to create the WOW factor at the same time. The lesson here is that when different artists draw the same character based off the same story, the character designs will be quite similar.

PRO TIP!

There's really no wrong way to do things in art as long as you're confident with the thing you like to do.

—Ashley Erickson

We made it to the end of the book! Now it's time to take a breather. That was a lot to take in.

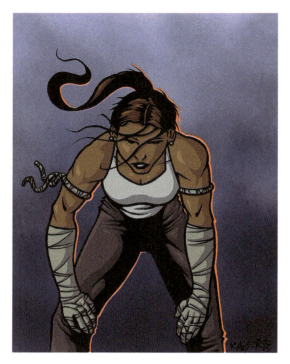

I hope you learned a few things about character design. I hope that after taking the time to read this book and get a strong foundation about what is needed to make strong characters and to be a great character designer you are now ready to go out in the world and let people see your artistic genius. Now it is time for your homework. You didn't think you were going to get away that easy, did you?

Homework Time!

Your homework assignment is to go forth and create characters you can be proud of. Have fun and always remember one thing:

Interviews

I always think that it is a great idea to have different perspectives on the same subject matter. Since we have been talking about character design, I thought it would be a great idea to get some different perspectives from some industry professionals in the entertainment field. I was able to get a group of very talented people together:

Elvin Hernandez
Chris Scott
Bakia Parker
Robyn Williams
Colin Byrd
P. Mavinga
David Silva
Ashley Erickson
Scott Prescott
Bun Leung
Enrique Rivera
Danny Araya

I asked them 10 questions about character design. Seeing the different views and the similarities in design process is very refreshing. Make sure you read through this question-and-answer section carefully; there is a lot of great information here.

Elvin A. Hernandez

Professional Educator, Sequential Artist, and Illustrator

Instagram: @eahernandez_art

Best known for in the art industry

I have written the book *Set the Action!* for Focal Press, which discusses dynamic background design techniques. I have also worked for companies such as Toys 'R Us, Upper Deck, and Cryptozoic, developing material for projects and clients that include Marvel and DC. I have also worked with Kaiser Studio Production for close to 10 years and in postsecondary education for over 11 years.

Character Design Questions

When initially coming up with a character, what is your process?

It honestly changes per character (as some characters are built more on design and iconography, while others are built straight from a personality that I want to put on paper), but in all cases the story tends to come first (or at least the first germ of a story). Once I have an idea of what the conflict in the story is going to be, I can get a sense of character ages, personalities, and other characteristics that would eventually inform the design.

If you start drawing first, when the story comes into play does your design change?

The design changes as I get a better handle of the story, but honestly, once I get an initial idea in my head, I just tend to expand on it. It would need to be a dramatic change in the narrative, or a conversation with the writer or art director, for me to change the initial design if it fits the story in question.

How important is story to your design process?

Story is everything; you can make a character look as cool as you want, but without a proper narrative, the character remains flat.
Even more important is the conflict within the story (both internal and external conflict). What is your character fighting/facing and why really do build on the design, as each character reflects conflict differently. A dark, brooding character will have different motives than an altruistic, noble character, and this affects the design.

Do you pull certain attributes from iconic archetypes to help your designs?

Absolutely. The whole Joseph Campbell concept of the classic heroic figure against shadow characters still works perfectly. Also, pantomime and posture help sell design and composition; you can tell who's the villain and who's the hero by how they stand, run, and move. Yet you can also play with those expectations (making heroic characters behave in mysterious fashion or making a villainous character regal in posture).

When designing characters, how important are the use of shapes and developing a strong silhouette?

This actually continues my point from the last question: when we see characters (or really anything), we tend to notice shapes and forms first, then interiors and details. Because of this, their pose, their basic form, and their build can definitely make characters memorable as well as help in creating a defined impression on an audience. Yup, silhouettes and shapes are essential for my work.

When designing characters, do you design in black and white and then go to color or work with color from the start?

Normally I start in black and white; sometimes I don't even know what the colors are going to be until I'm done. There is something to be said for having a character work in line art before adding the extra layers of coloring. But yes, black and white tends to come first.

Should you cater to your audience when making characters or just design what you like?

This one is honestly a "depends" sort of answer: I like the creative process and I really like coming up with my own designs at my own pace. However, I do understand that I am part of a process when working with larger companies that are looking for character concepts. Because of this, I still need to think of the needs of the client as well as the purpose of the piece. However, I am always dictated by the needs of the narrative; the story that is being presented must always jive with the design constructed for the piece.

Using reference is a hot topic when it comes to character design. What is your stance on using reference?

Yes! Reference is absolutely necessary! Look, you don't have to reference everything (sometimes you can formulate posture and form based on years of practice, life drawing, and professional experience), but backgrounds, angles, and anatomy of figure are still necessary for every piece and will require some homework. Plenty of times I've actually retrograded reference, where I've drawn a figure and then I've gone back with reference to refine and correct the form. Also, if working in color, do get a color wheel (trust me!).

When designing a character that was created by someone else, do you like the description to be very detailed or open for interpretation?

It honestly depends on the needs of the story; I've been lucky to work on projects such as the *Dark Legacy* card set where I've been encouraged to work from my own reactions and instincts regarding a name or a concept (I'd usually get the name of the card, the type of character that may be portrayed, and then use my imagination for the rest). However, if there need to be key pieces in the design for storytelling purposes, I need to know them first. Also, if there is a model or body type established by a previous illustrator that is part of the production, I need to make sure that I can match it and maintain its integrity. Honestly, you get all kinds of assignments, which require you to problem-solve differently.

If you had that golden nugget of information that you would pass on to other character designers, what would that be?

Understand your story and your conflict; once you know who your character is and what their purpose is within the story, the research and design process will become clearer. Also, don't overcomplicate the design if the character doesn't require it; a character can look cool without being overly detailed to the point where you lose their personality.

Chris Scott

Independent Comic Creator

Instagram: chrisjamesscott1

Twitter: Chrisjamesscott

www.chrisjamesscott.com

Best known for in the art industry

Two Ton Rock God. The story of musicians who use instruments to pilot super fighting robots in a battle of the bands unlike any other.

Character Design Questions

When initially coming up with a character, what is your process?

The face. For me, it's highly important to get the face (and really, the whole head) right. In my mind, any character can change their clothes at any time, so I try not to get married to the idea of "nailing the whole look" initially.

If you start drawing first, when the story comes into play does your design change?

Yes. But if I feel strongly enough about a design, I'll try to reshape elements of the story to make the design more congruent. The reverse can happen as well! If the design just *does not* fit the story, I'll rework the design to fit the story. I guess you could say it's a constant juggling act between form and function.

How important is story to your design process?

Very! A cool design without appropriate context is *just* a cool design. The story is what can allow an audience to invest in your character. And if the design doesn't appropriately complement the story, (and vice versa), then you're wasting time.

Do you pull certain attributes from iconic archetypes to help your designs?

Absolutely! One of my go-tos is using bare arms to accentuate a character's physical power and strength. To me, bare arms on certain designs signifies a very particular type of unglamorous, no-frills strength that typically involves grappling, street fighting, ungloved boxing, etc.

However, that's just one example out of the plethora of archetypes available to choose from. I believe that there are no overused archetypes, merely bad executions. So I say the best way to figure out which archetypes work best for your particular project is to get out there and mix it up.

When designing characters, how important are the use of shapes and developing a strong silhouette?

It is critically important. A strong silhouette can tell you *everything* about a character. Think of some of the most iconic superheroes. You can *absolutely* spot them from a silhouette. Many factors play into this: posture, hairstyles, clothing, etc. Chances are if you start out with a strong silhouette, it'll do most of the initial heavy lifting for you while designing.

When designing characters, do you design in black and white and then go to color or work with color from the start?

Always black and white. If I can't picture the character in monochrome, then I can't really start to add colors to it. Since colors can say just as much about a character as anything else, I need to have a clearly defined design to work with before I start deciding on color choices.

Should you cater to your audience when making characters or just design what you like?

If doing work for a client? Yes. You want to stay true to the aesthetic that has earned that client their audience. If designing for yourself? No. I feel that when you start doing that, you run the risk of the design being weak and without energy.

Using reference is a hot topic when it comes to character design. What is your stance on using reference?

Use reference as a tool to help you on the path to finding your way *to* the final design. Don't simply copy the reference, but really analyze what you think works and doesn't work about the reference material. If you're designing a classical superhero, then you're going to want to infuse your design with traits that have won people over for decades.

When designing a character that was created by someone else, do you like the description to be very detailed or open for interpretation?

I love detailed descriptions of the character's personality. What do they want? What is their general means of acquiring that goal? Story-based traits that aid me in crafting a complementary visual. But I absolutely prefer a clear, focused direction when it comes to client work, because the interpretative route generally feels like I'm doing some of the problem-solving that they should've already handled.

If you had that golden nugget of information that you would pass on to other character designers, what would that be?

Don't be afraid to challenge yourself. Think of out-there, wild, and crazy designs. Think up characters that don't immediately appear to be from the same universe, let alone the same story. Then see if you can't mold both/either the story or the designs to work alongside each other. And remember to *always* balance form and function. Anything too much to either side and you'll end up too flashy or too boring.

Bakia Parker

3D Artist and Maker

http://bakiaparker3d.com/

Instagram: https://www.instagram.com/singledigit_studio/

Facebook: https://www.facebook.com/SingleDigitStudio/

Best known for in the art industry?

Hard surface modeling

Character Design Questions

When initially coming up with a character, what is your process?

Regardless of what the setting or genre is, the initial foundation of my characters is based on some personal experience like an inside joke with friends, or an exaggeration of one or more people I know personally. Your personal experiences and people around you are a great place to draw inspiration for character designs. This always adds a layer of believability and relatability to a character. There is a reason why character archetypes like the geek, the jock, the mentor, the love interest, the girl next door, or the unpredictable uncle at family reunions are all archetypes that have stood the test of time.

If you start drawing first, when the story comes into play does your design change?

Absolutely. You have to be flexible and willing to let story dictate certain design elements without being too attached to your original idea. Your best designs usually come from that "aha" moment when a story element sparks an idea for the character's design.

How important is story to your design process?

Story is a vital part of a character's design; however, the key is to be selective about which aspects of your character's story are reflected in the design. Is it more important to focus on the character's heritage/culture or the character's lifestyle/personal experiences? The most common mistakes I've seen are putting too much story in your design or not putting enough. You end up with either an overdesigned character or a bland character. There is kind of a fine like to walk here.

Do you pull certain attributes from iconic archetypes to help your designs?

They are "iconic" for a reason; use them. Similar to drawing inspiration from the roles people in your personal life play, character archetypes are very much the same way. They are a great stepping-stone on which to base a character's design. Don't be afraid to combine these archetypes to create unique characters such as "the girl next door" who just happens to be a "dark lord." That's probably not the best example, but you get my drift.

When designing characters, how important are the use of shapes and developing a strong silhouette?

Silhouettes are a tricky thing. It's not high on my priority list when developing a character, but it is something I'm still aware of as I work. But you can't deny the gravitas that a good/strong silhouette gives a character. Look at characters like Goro, Wolverine, Mickey Mouse, Iron Giant, Bugs Bunny, Bart Simpson, and Batman, all characters with iconic silhouettes.

When designing characters, do you design in black and white and then go to color or work with color from the start?

I start with black and white before transitioning to color.

Should you cater to your audience when making characters or just design what you like?

Both. More often than not, artists draw and create the things they like. This is great for personal portfolio work. This helps showcase your talent and your voice as an artist. On the flip side, when an artist gets into the job field or creating art for money, this is where the audience comes into play. You have to cater to them without losing your voice as an artist. This also applies to job prospects as well. If you want to apply for a job as an inker on a manga series but do not have any examples to show, it would be in your best interest to draw and ink a few characters in the style of the IP [intellectual property] you want to work on.

Using reference is a hot topic when it comes to character design. What is your stance on using reference?

This is a simple one. *Use reference* if you want to stand a chance of becoming a great artist. You simply cannot create something believable if you do not know what it looks like. It's silly to expect an artist to accurately create everything memory. If I've never seen an M-15, there is no way I'd be expected to draw one accurately solely based on my general knowledge of guns. What I'm trying to say is, use reference regardless of if you are a 25-year industry vet or a student in his/her first art class.

When designing a character that was created by someone else, do you like the description to be very detailed or open for interpretation?

A bit of both. As a 3D artist, this is an issue I face frequently. The more information I have of the character, the easier it is for me to deliver what the creator wants. However, I do like to establish early on that there are always elements of a character's design that look awesome in 2D but don't translate well to 3D. So having some room to take artistic license and troubleshoot those issues is always a good thing.

If you had that golden nugget of information that you would pass on to other character designers, what would that be?

A good artist borrows; a great artist steals (if you need me to explain this, hit me up).

Robyn Williams

Full-Time Convention Artist/Owner of Byte Size Treasure

Instagram/Twitter/Facebook: @bytesizetreasure

Best known for in the art industry

I draw cute sharks and other sea creatures to sell at conventions around the country. I use my art to educate people on the importance of sea life and conservation.

Character Design Questions

When initially coming up with a character, what is your process?

One of my first steps when starting a character design is considering my audience and knowing what the final medium is going to be. As most of my character designs in recent years have been targeted for kids and all ages and the final work tends to go on merchandise, I keep my designs simple and impactful, mostly focused around basic shapes and bright colors. The animal-based characters I create are often based on their real-world counterpart, so I do my best to keep them true to life, but also exaggerate their characteristics to help my audience identify with the character's personality. To help define personalities of animals, I imagine them as people, sometimes relating them to people I know. This step is important for the audience to help relate to characters, especially if the character is not a human.

If you start drawing first, when the story comes into play does your design change?

Typically, my characters are designed hand in hand with their story. However, that's not to say that stories won't change over time—so if it comes down to it, I know that I will need to be flexible and change the character's design to fit better with the story.

How important is story to your design process?

For me, having a basic bare-bones backstory is pretty important during the designing of said character. Sometimes I find myself designing characters with no story as a means to sharpen practical skills. These practice exercises have helped me realize that coming up with a basic story helps me overcome hurdles and keep me focused on the design process. I remember one of my characters changed a lot during her design process after talking to people from the region of the world in which the animal she was based on was from. It helped me solidify her with that culture and made for a stronger design in the long run.

Do you pull certain attributes from iconic archetypes to help your designs?

As weird as it sounds, not really. Most, if not all of my characters don't fit into the "typical iconic" archetypes, such as the hero, the villain, or the mentor. My character designs tend to be more focused on secondary and tertiary archetypes. For example, I don't focus on the fact that the character is a "hero," I focus on an attribute of the character, like musician, student, a grumpy old man, or quirky personality.

When designing characters, how important are the use of shapes and developing a strong silhouette?

I think using shapes and silhouettes is one of the most important aspects to character design and showcasing your characters personality—even though color can be interpreted in different ways from culture to culture, shapes have more universal meaning across the globe. Round shapes are friendlier and endearing. Square shapes are more reliable, solid, and confident. Triangle shapes can be seen as cunning, dynamic, or aggressive. Combining these shapes and adding variance in the sizes of shapes can help you say so much about your character without saying a word.

When designing characters, do you design in black and white and then go to color or work with color from the start?

Usually, when designing my characters, I use a monochromatic color range like dark blues or dark purples—I rarely use black and white. Sometimes I just know what colors I want to use; other times, I experiment with blending colors—so having a colorful "base" helps keep my colors from getting muddy during planning stages. I also don't use black in any of my final artwork, so it's helpful to keep it out from the very beginning.

Should you cater to your audience when making characters or just design what you like?

I personally like happy, child-friendly design, and that's typically what my character designs cater to. That's what works for me. I absolutely recommend keeping your audience in mind when designing characters. Designs aimed at young children work best when they're simple and brightly colored. Keep the intricate details and features for older audiences.

Using reference is a hot topic when it comes to character design. What is your stance on using reference?

I will always always always recommend any artist to use reference. Whether you need reference for a pose, for lighting, for anatomy—I find it's very important no matter what. Don't rely solely on the reference, though; it's there for your benefit. Once you start using reference material, your characters will become more diverse. For myself, as most of my recent work is animal based, I spend a lot of time researching and gathering information and inspiration before I start creating characters of each animal I design. This is to make sure that I'm accurately portraying that animal anatomically. A portion of my audience are people that study or work with the animals I draw, so I need to make sure they're correct or I'll be eaten alive.

When designing a character that was created by someone else, do you like the description to be very detailed or open for interpretation?

If I had my way, I would love to have a design brief that's more detailed than open. Typically, people who I'm doing design work for already have attributes in mind for what they want, and I'd love to have all that information—even if some of it isn't necessary or can be scrapped.

If you had that golden nugget of information that you would pass on to other character designers, what would that be?

Don't aim for perfection. You're not Borg. There's no such thing. But practice does make proficient.

Collin Byrd

Independent Cartoonist (primary), Adjunct College Professor (secondary)

Patreon: http://www.patreon.com/skipperwing

Web Anicomic—The Crimson Fly: http://www.thecrimsonfly.com

YouTube: http://www.youtube.com/user/skipperwing

Twitch Streaming: http://www.twitch.tv/skipperwing

Instagram: http://www.instagram.com/skipperwing

Best known for in the art industry

2D animation, specifically the Crimson Fly anicomic (animated comic)

Character Design Questions

When initially coming up with a character, what is your process?
- Decide on their place in the narrative of the story.
- Figure out what their motivation is, specifically how it supports/complements/contrast the main protagonist (if they aren't the main protagonist).
- Create a background within the world for the character that justifies their motivation.
- Choose personality traits that best mesh with both their background and their motivation.
- Sketch body types and attributes that best convey their personality and/or motivation.
- Sketch clothing that supplements and conveys their personality and background.
- Research similar characters in fiction for body type reference.
- Research similar clothing in real life and fiction for clothing reference.
- Research real-world locations and time periods for the character's background.
- Sketch multiple expression and action pose sheets to become familiar with the character for professional use.
- Finalize designs with turnaround model sheet and illustration/animation breakdown pages.
- Experiment with multiple color schemes for the character, based on color theory and cultural meaning.
- Finalize color designs in character turnarounds, action poses, expression sheets, and design breakdown.

If you start drawing first, when the story comes into play does your design change?
N/A: Story and narrative concept comes first.

How important is story to your design process?
Story is the most important element of my design process, because I believe in the notion that "form follows function" and that a character/object's physical appearance is contingent on/informed by the necessity of their apparel and/or accessories in their life or story. Story also imposes "theme" on characters, and thus streamlines most of the design process. And thus a character's design and/or appearance is contingent on their role in the story.

Do you pull certain attributes from iconic archetypes to help your designs?
Yes. Iconic attributes, like shape, body type, and color theory, provide an easy shorthand for character design in both creator and audiences' minds, thus allowing both to focus on the character's role in the story, rather than trying to decipher what that (their role) is. Also, using established archetypes doesn't pigeonhole character design, because the archetypes can be mixed and matched in infinite configurations or subverted by the narrative, thus allowing for audience surprise and creator flexibility.

When designing characters, how important are the use of shapes and developing a strong silhouette?

The use of shapes, in and of itself, and creating strong silhouettes are paramount in character design because silhouettes are the simplest form of the character, and their easiest identifier. Characters with strong silhouettes stand out from their contemporaries, and are thus easier to remember. Shapes make this process easier because shapes create an easy blueprint to construct character silhouettes, rather than having to focus on minute details as character identifiers.

When designing characters, do you design in black and white and then go to color or work with color from the start?

I start primarily in monochrome out of convenience; it's easier for me to design in line without thinking about color, and then apply color afterwards, rather than having to think about line, shape, and color all at the same time. Also, I find that, until the process is finalized, color is more easily mutable than line, shape, and/or silhouette.

Should you cater to your audience when making characters or just design what you like?

Ideally, designing the preferences of both you and your audience would be the same, since you are designing what you like for people who also hopefully like the same things you do. However, in situations where those tastes diverge, or the audience isn't allowed to know the character as you design them, the creator's preferences take precedent, as, in theory, the creator knows more than the audience does about the purpose of the character. The creator should be versed in design theory, audience psychology (as it relates to their craft and their product), and how context and theory inform their own tastes, and the character's role in the story, which gives them a design advantage the audience doesn't have, and makes them more informed in designing a character both they and the audience will enjoy.

Using reference is a hot topic when it comes to character design. What is your stance on using reference?

I think reference is acceptable in confirming or expanding on design choices that have already been made in regards to the character. Ideally, reference should supplement inferred details about the character, such as their clothing, the time period they belong to, or references to people/characters the author wants to use as shorthand for how audiences should feel about the character (for example, making your character resemble Joe Pesci as shorthand for short-tempered, overcompensating, troubled individuals). Specific reference to other characters (in regard to primary motivation/background or personality) should not be used as the jumping-off point for design, lest the designer's character be negatively compared to the character they are based on.

When designing a character that was created by someone else, do you like the description to be very detailed or open for interpretation?

I personally prefer the design to be as specific as possible, as there is little guarantee that the owner's ideas for the character will align perfectly with my own. The more specific the design, the easier it is to comply with their wishes. That being said, I do believe in a small leeway (30%–40%) being offered to the designer, for corrections to ideas that sound good on paper but do not execute as well in illustration.

If you had that golden nugget of information that you would pass on to other character designers, what would that be?

Keep your designs as simple as possible. Simple designs are easy for other creators to reproduce and easier for audiences to remember.

J. P. Mavinga

Concept Designer

Instagram: @jpmavinga

Facebook: facebook.com/jpmavinga

Twitter: twitter.com/mavinga

Best known for in the art industry

Good question

Character Design Questions

When initially coming up with a character, what is your process?

First, I try to hold on to the strongest emotions the story evokes in me. From that, I gesture out a general and quickly try to further resolve some aspect of the character that promotes that still present emotional resonance for me. Often this is a face or an expression, but it can also be stance or a feature. I then work from that element out, trying to stay in that state of mind while pursuing impressions from story.

If you start drawing first, when the story comes into play does your design change?

I don't draw or create very successfully without at least some sense of a story. It's why I started drawing characters in the first place.

How important is story to your design process?

Story is everything.
If one isn't supplied for a job, I'll still work from a story of my own. Story really is everything.

Do you pull certain attributes from iconic archetypes to help your designs?

As a routine practice, no, I don't think so. I try to tailor my approach to serve the story. That being stated, I'm not sure to what extent one can fully escape the iconic and the archetypical.

When designing characters, how important are the use of shapes and developing a strong silhouette?

The use of shapes and silhouette is key to the initial impression of the character. Still, it depends on the media and the situation. For me, when these encompass gesture or stance, the sense of movement, volume, and drapery (if any), the language of the character can be successfully captured pretty quickly.

When designing characters, do you design in black and white and then go to color or work with color from the start?

I generally work by way of line drawings. I explore composition and movement without color. Where color would be a primary element ahead of other aspects of the character, naturally, I would approach that work with color first.

Should you cater to your audience when making characters or just design what you like?

In many settings, the first audience is a client or boss, so it's best to reach that audience. It's important to understand that any audience is pleased by surprise to some degree. The relationship between the familiar and the unexpected is key in many domains, including music, visual art, and storytelling. It also holds true in design.

Using reference is a hot topic when it comes to character design. What is your stance on using reference?

This depends on usage. Take one extreme: for most people, tracing isn't likely to produce a new solution. Still, it may be possible for minds to find a novel solution even in that process. More broadly, it's better to use reference if there is a need for something specific that isn't readily available by memory, or just for confirmation. There is no disadvantage to supplementing the memory; sometimes details make all the difference.
For the student or novice, however, observation from life will generally produce better habits and better results long term.

When designing a character that was created by someone else, do you like the description to be very detailed or open for interpretation?

Ideally, the design serves the story or purpose of the character. A description can still lack story or broader context that can serve both reasoning and the imagination. Either way, I think what's most valuable is a story.
Story is everything.

If you had that golden nugget of information that you would pass on to other character designers, what would that be?

Look at something else. Look far and wide. Referencing work that's been done is problematic specifically because it has been done. The outcome is likely to be derivative. In order to be innovative, one must look elsewhere. Ideally, pretty far in order to find new combinations and new solutions. Sometimes that means doing more research; other times that means looking internally and getting out of the way of the unconscious.

David Silva

Owner of Creative Beast Studio, Action Figure Designer/Sculptor

Facebook: Creative Beast Studio

Instagram: @creativebeaststudio

Twitter: @Beast_SculptKit

Best known for in the art industry?

Creature-related toys such as dinosaurs, dragons, Godzilla, and Predator

Character Design Questions

When initially coming up with a character, what is your process?

For me, the story concept comes first. From there I break it down into what needs to happen and which characters will take those actions. The characters are essentially defined by the actions they take in the story. Their motivations for those actions make up their personality. From there I can build an appropriate appearance for that personality within the context of the story environment and the physical role they play in it.

If you start drawing first, when the story comes into play does your design change?

I would never suggest drawing first unless it's for an exercise in storytelling. Drawing your character first will challenge you to create a good story. Develop your story first and that will challenge you to create good character designs.

How important is story to your design process?

To me, story is everything. Context is my main inspiration for creative character design.

Do you pull certain attributes from iconic archetypes to help your designs?

I'm sure I do this subconsciously as I believe we're all influenced to some degree by stories and characters we've enjoyed. Many of our favorite characters are usually archetypes on some level because these are often the ones that move the story forward in the most meaningful way. But we must be careful not to fall into the trap of clichés and overused tropes. You can have your underdog hero, your honorable villain, etc., but be sure that they serve the story and add something new to the formula where possible.

When designing characters, how important are the use of shapes and developing a strong silhouette?

Very important. The main shapes give the audience their very first impression of the character. The silhouette shows what the character is about at a glance—a "visual summery," if you will. The main shapes and the posture are key to communicating an essence of what you can expect upon learning more.

When designing characters, do you design in black and white and then go to color or work with color from the start?

I always start with a loose pencil sketch and build up from there to a color rendering. It's important to focus on the general design of the costume before designing the colors. For me, the entire character design process can be broken down into this order of steps: story concept—story outline—character descriptions—pencil sketch—tight drawing—color studies—final render.

Should you cater to your audience when making characters or just design what you like?

If you are creating a character for your own story, make sure that you are a part of the audience which you are creating it for. This way your design remains genuine and you can

stick to your strengths and interests. For example, I'd have a difficult time designing a horror character because I'm not into that genre. However, I'd be very comfortable designing a cyborg ninja. Basically, keep your aim genuine and you won't have to concern yourself too much with what the audience wants because you already are that audience.

Using reference is a hot topic when it comes to character design. What is your stance on using reference?

Use it. All of the time. There is no excuse not to use reference for anything, especially nowadays. Don't trace it or copy it, but use it to inform what you're doing at all times. Using it for anatomy and drapery should be obvious. Even if you're designing a sci-fi or fantasy character, you can research hi-tech machine parts or medieval armor and weapons. If you're not using reference, you'll never realize your true potential as an artist.

When designing a character that was created by someone else, do you like the description to be very detailed or open for interpretation?

Personally I can't get into it unless I'm given some creative freedom to bring something new to the character, so the less restrictions, the better.

If you had that golden nugget of information that you would pass on to other character designers, what would that be?

Something that was never taught to me that I would gradually come to understand over time is something I call "design rhythm." It's what keeps a character design cohesive and consistent throughout, from the "costume" to the accessories. There should be a harmony of shapes and details that visually describe who the character is and where they exist. For example, you don't want to have a character made mostly of sharp angles with a round helmet because it's unpleasant to look at, even if you can explain it within the story. You can also look for a motif that can be echoed throughout the design, like a shape or pattern. Or perhaps it's simply a matter of balancing the busy areas with simple areas. If there is harmony in your design, it will look correct without even having to know the story. You must be aware that while this rhythm is subtle and mostly subconscious, if the design is in conflict, the character will be less appealing to look at and thus less interesting. This is a skill that has to be honed with practice and is easy to overthink. In the same way that the story should have a consistent tone or style, so should the visual story of each character.

Ashley Erickson, online as Cloverkin

Independent/Freelance Artist; beforehand spent 10 years in the game industry

Instagram/Twitch/Facebook/Tumblr/Etsy: Cloverkin

Twitter/Gmail: CloverkinArt

www.Cloverkin.com

Best known for in the art industry?

Pet in Armor Portraits (bit.ly/petsinarmor) and fantasy work

Character Design Questions

When initially coming up with a character, what is your process?

It depends on what it's for. Character design can be dependent on its final form. Going about it for a book versus a game has a different process. Overall, it's important to factor in the story (assuming it already exists). If not, the main questions to ask are the who/what/when/where/why/how of this character. Are they human, creature, alien, other? What is their job? In what era do they live? Where do they live, work, relax, etc.? Why are they doing what they're doing?

If you start drawing first, when the story comes into play does your design change?

Absolutely and it should. Character and story are very tightly bound. I would say if you make a character first, the story should be able to follow suit behind it and the character should be able to make a lot of decisions that will change the course of the story. Sometimes I'll have an idea for the story, but then I make the character and certain parts change because the character "tells" me it should. A good character will lead your story. As a storyteller, you have to be flexible and allow the story to breathe and change. If you try to force characters and elements in that don't fit, the audience will feel that. You have to be able to understand that the story will change and potentially start writing itself. At that point, it's your job to transcribe what it tells you. I know it sounds crazy, but really it ends up sort of writing itself.

How important is story to your design process?

Extremely important. A good story will explain a character visually and vice versa. Know that everything in your story is technically a character. People, places, buildings, objects, etc. A "story" is technically any experience something has had. A teacup may have chips, cracks, and be muddy. That in itself is already telling you its story and all those things are design elements.

Do you pull certain attributes from iconic archetypes to help your designs?

Sometimes. Not on purpose usually. A lot of things are tropes because they end up falling into archetypes despite your intentions. And that's alright, but make sure you're still developing an interesting three-dimensional character that has aspirations, intentions, and depth. A villain that's bad because he wants to be is a very flat, two-dimensional character. Give him a family he's fighting for and already he's become a lot easier to empathize with.

When designing characters, how important are the use of shapes and developing a strong silhouette?

Incredibly important. You have to know what kind of emotion and attributes are coming across through body language before you even show any adornments or costume. A giant, hulking silhouette with its arms raised to the sides looks very aggressive, while the same figure with the arms pulled in may paint a different picture. Maybe he's holding a butterfly gently. Two completely different characters with just a smidge difference. You really need to think of all aspects of a character while designing them as every little piece is a part of the puzzle that is them. But that's also the fun of it!

When designing characters, do you design in black and white and then go to color or work with color from the start?

It really is up to you. I'd say to start with whatever is most comfortable to you. Character design is *not* dependent on what medium you use. However, know that if you design a character in grayscale that's very strong to start with, they'll only get stronger with good color choices.

Should you cater to your audience when making characters or just design what you like?

Never cater with your art. Art is for you first and foremost. After it's been created and once you let it into the world, it's for others to enjoy. If they like it—awesome, if they don't—that's fine. Everyone has different tastes. Don't take it personally if someone isn't into your art. You may be fantasy; they may be sci-fi. Just because they don't dig it doesn't mean it's bad. You never need someone else's opinion to justify your art. The only validation you need is your own. Did you have fun on it? Did you express what you needed to? Great! Just know that it's about always doing what you want and others will follow with similar tastes. Let's say you always drew what was popular or did fan art. (Which you shouldn't do because it's not only illegal, but it steals time from you and your own art journey. Please refer to this site for more info on that: www.fanartfree.com.) If you got followers or likes because of those things, those people aren't loyal to you and what you're about. They just like that thing because it was already something they enjoyed before they saw your work. In other words, you're playing off their nostalgia, which is even a bit manipulative. And think about it, the minute you switch what you're doing and start doing what you like—those people will most likely leave. They have no loyalty to you because they won't necessarily like what you are really about. That's why it's smart to always be true to you and what you like to do because then you know the follows and likes you get are genuine. They're there for you, your art, and what you have to express to the world.

Using reference is a hot topic when it comes to character design. What is your stance on using reference?

Reference is always fine and encouraged. However, there is a good way to use it and a bad way. I disagree that it's a "hot topic." I think reference is always 100% a good idea. The problem arises when people become dependent on it. There's a thing in the art industry referred to as your "visual library." This is where everything you've ever drawn is stored. If you're drawing from reference and not thinking about what you're drawing, you're not actually studying it and you're just regurgitating what you see. A good artist will be studying as they're looking at the reference so they actually digest what they're seeing. They'll be able to call upon it later. If you're dependent on reference, the best thing you can do is start weening off of it like this. Look at the reference, draw it while taking mental notes about where things are and why they're doing what they're doing, then take the reference away, redraw it without it, then compare. That way you get used to not having the reference there. Don't be one of those artists that draws page after page of limbs, eyes, and hands. That won't help you in the long run. Instead, make a small piece that you can use as a study of many things that you can eventually sell or make something more of. Sometimes I'll decide to do a piece that comprises things I haven't drawn before. During that piece I'll be looking up references and trying to figure out that particular object and how it works and why it is the way it is as I fit it into the composition. You don't want to always be studying elements on their own; that won't help you in the long run. You want to know how they fit together. Good composition is important to character design and story as well. Even when just showing a character's prop, you'll want to show that at an angle that gets the most of what it's about across. So in my opinion, always use reference—just don't get dependent. Be able to draw things from your mind. That requires you to strengthen your "creative muscle," we've been calling it. The more you do original ideas from scratch, the better you're going to get at brainstorming them. If you're always redrawing someone else's characters, you're never going to get better at it. It's almost like playing with dolls. So make sure you're always thinking of new characters and stories to strengthen that muscle.

When designing a character that was created by someone else, do you like the description to be very detailed or open for interpretation?

I think it depends on your level as a character designer and what job you have. I think as you get more experienced, having it more open-ended is ideal. If you get commissioned by someone to draw their original character, it's nice to have a few "must haves" but also

a couple of "if you wants." It's really going to depend on the job you get, however. Not all character design jobs are the same, though the one thing you can count on with character and concept design is that you'll need to be used to thinking of tons of ideas and be able to throw them away at a moment's notice. You need to get used to the idea of "disposable art and ideas." You'll have to do 100 designs, let's say, then the art director will tell you to elaborate and iterate on 10–20 of them, then you make more designs closer to those, then the process happens again and again until only a couple are left. I think it comes down to being an artist to artist thing. Some artists prefer a lot of direction, others not so much. So it depends on what industry they're in and what they like to do. There's really no wrong way to do things in art as long as you're confident with the thing you like to do.

If you had that golden nugget of information that you would pass on to other character designers, what would that be?

I have a couple things actually and not just for character designers. Also, if any of you like what I've been saying and enjoy the next bit, feel free to come to my Twitch channel. We talk about this stuff *all the time*. It's why I'm in full-rant mode, ha ha. I don't even just see any of this for *just* character designers; it's for all artists. First and foremost, know that fan art is just training wheels. It's for experimentation until you find a style to jump off from. It's not "what you need to do" to get hired to draw Spider-Man, etc. If Marvel likes what you're doing and sees you're a good artist, they'll just know that you can also do Spider-Man. Too many people think you need fan art to get into the industry and that's 100% wrong. Be a good artist. And by that I mean be a *true* artist to yourself. Second, you don't need *one* style. Don't be worried about finding *your* style. You'll have so many over the years. You'll have a ton for different things. My marker style is different from my watercolor style is different from my game art style. Don't feel pressured to be any one thing. You can do whatever you want and make it work. You just have to be confident with it and find the right demographic. Third, cater your portfolio to what *you* like. If you can do illustration, 3D, animation, etc., cool, but don't put all those in your portfolio if you only want to do illustration. Think about it, you go in for an interview, they see you can do 3D and offer you a job. You're hesitant because you don't want to, but you take it anyway. Thirty years later you're still doing it and hate it. Think if you had catered your portfolio to just be illustration. You'd just be doing illustrations. Stay true to you. Do what you like to do and you'll be hired on for it. Remember that social media is not only to show final pieces but to show that you produce. It's a way to prove how often you produce things. Take Instagram, for example. It's a platform built on the idea of past posts getting *buried*. So use Instagram to prove how often you make things. Use an actual portfolio site to showcase your best work. Remember that your best work should be between 10 and 20 pieces. Quality over quantity. The quantity over quality should be on your Instagram. Let people see your work-in-progress and your sketches. Instagram is not a gallery; it's a living thing. Use your domain as your gallery and your social media as your sketchbook. Fourth, in general, remember not to go too big right away *ever*. Start small, start cheap. If you go for giant paper and canvases before you know how to properly use composition or shape language, you're going to have a ton of wasted time and materials. Instead, start on smaller paper, like 4 × 6, and master it there first. You'll go through so many more drawings, aka experiences, than if you had done one giant piece. Think about it like an RPG. Let's say you're level 5 but go up against a level 10 boss; you might win, but it's a *super* slim chance. Now instead, wouldn't it be smarter to grind on smaller enemies and level up closer to that boss? I think so. Think of all art like that. Kick out more things to learn quicker. The timeless "fail faster" concept. When you're learning in the beginning, it's all about quantity. Draw, fail, draw, fail. And know that failing isn't a bad thing. Don't let what anyone says alter that in you. Failing is good when it's on the road to learning. You need to know what not to do as much as what *to* do. Also, small endnote: don't press too hard on your pencils. Use the 80/20 rule here. Eighty percent light until you've mapped everything out without question where it'll go. Then go over it for the last 20% with darker lines and put your line variation in during this time. It'll make it a lot easier to erase in the beginning stages if your pencil lines are soft and light. One last bit, if you're one of those people afraid to "ruin" your sketchbook, this advice should help. Open the sketchbook to the first page, take a marker or anything else, and utterly destroy it. Scribble all over it, make it ugly. That's the bar now. Any drawing afterward will be an improvement. Sketchbooks are meant to be messy and full of ideas. They are not meant to be masterpieces. Remember that. Get your ideas down any way you can. Any time I flip through a messy, beaten up sketchbook, I know it's been loved. It's a visual diary.

Steve Prescott

Artist

Instagram: @thesteveprescott

Best known for in the art industry?

Fantasy gaming artwork—specifically for *White Wolf*, *Dungeons & Dragons*, and *Magic: The Gathering*

Character Design Questions

When initially coming up with a character, what is your process?

I assess the parameters of the job and then try to come up with a character as interesting as possible within that. I try to avoid anything that comes off as generic or as being seen too often before.

If you start drawing first, when the story comes into play does your design change?

My design may change for any number of reasons as the drawing moves along. Sometimes it's the pose, sometimes I'll just get a spark of inspiration from somewhere else, sometimes the drawing just isn't working anyway and I need to shake it up. And yes, if there is a story that goes with the character, that can affect the design even more.

How important is story to your design process?

In a sense that you want a character to be interesting to the point where the viewer can sense that there is more to the character than just taking up space, it's very important. I want a character to appear like he or she or it has a whole life—a career or skill, a past, a range of moods, dispositions, quirks, etc. All these things tell a story within the character's design and heap on the intrigue.

Do you pull certain attributes from iconic archetypes to help your designs?

Yes, but I try to push as much as possible where the archetypes allow. For instance, you kind of need a certain amount of visual cues to make a character fit a "pirate" role. And there are plenty of ways to just use *all* of those visual cues and now push anything too far and end up with a nice, boring, run-of-the-mill pirate. The trick is to pick and choose which of those things can be ditched or played around with and made more fresh without losing that pirate vibe completely.

When designing characters, how important are the use of shapes and developing a strong silhouette?

For me, it's essential. As a draftsman, that's how I roll. I break down designs into shapes and then smaller shapes and then interesting shapes, etc. Silhouette and negative space all contribute to making a striking and memorable character.

When designing characters, do you design in black and white and then go to color or work with color from the start?

I always draw it first. I rarely think in color. Get the attitude and the designs and the pose and the costuming right and the colors will fall into place.

Should you cater to your audience when making characters or just design what you like?

Design what you like as long as it fits the job. That's really how my job is as a whole—taking an assignment or commission and finding a way that allows me to do as much of what I want to do as possible. That amount may vary but I have to have room to do something I want to do—to run it through my filter and make it as much my own as I can.

Using reference is a hot topic when it comes to character design. What is your stance on using reference?

Depends on what kind of artist you are and how you like to make art, I guess. I personally use reference much more for inspiration and getting the basic flavor for things than getting exact ref with a photo-taking session and lighting and such. I will do that every once in a while, but I work in a very stylized manner, so sticking close to photo ref kills the energy I want to have. So yeah, I use ref but usually it's just open books lying around me on the floor and Google images on the screen with pictures of lizards legs or eagle wings or African weaponry or desert landscapes, etc.—just to keep those shapes and colors handy as seed ideas.

When designing a character that was created by someone else, do you like the description to be very detailed or open for interpretation?

As open for interpretation as possible.

If you had that golden nugget of information that you would pass on to other character designers, what would that be?

Whether with facial expression or gesture or pose or costume design or accessories or silhouette, try to sell as much fresh intrigue as possible in one character. No background imagery—no accompanying text. Just the character.

Bun Leung

Freelance Artist

Instagram: bunleungart

Best known for in the art industry?

I am an artist that travels the Comic-Con circuit. Most well known for my stickers.

Character Design Questions

When initially coming up with a character, what is your process? I like to gather all the information and the client's desires.

It is important to understand the clients, themes, moods, motivation of the characters, and such. You don't want to end up designing a dark character for a lighthearted story or vice versa.

If you start drawing first, when the story comes into play does your design change?

I usually try to ask for the story beforehand or at least a quick footnote of it. I stated previously that you do not want to get the mood of the character wrong for the mood of the story.

How important is story to your design process?

Very important. I will usually try to read through several pages of a script before I even think about taking on a design project. Sometimes you know what is out of your comfort zone. Don't want to bite off that which you know you cannot chew.

Do you pull certain attributes from iconic archetypes to help your designs?

I grew when anime was first hitting the scene so iconic anime looks and mech designs are usually a staple in my work.

When designing characters, how important are the use of shapes and developing a strong silhouette?

Typically, I like to predetermine a shape for the body type of the character.

When designing characters, do you design in black and white and then go to color or work with color from the start?

I usually have a pallet in mind, but it is very flexible. I definitely work in black and white first.

Should you cater to your audience when making characters or just design what you like?

You absolutely must cater to your audience. Unless you are at the upper echelons of the field, you need to make sure your customers are happy. Just like a chef cultivating a menu, you base your menu on the tastes of your customers at whatever specific type of restaurant you work in.

Using reference is a hot topic when it comes to character design. What is your stance on using reference?

We are all lying if we say we don't use reference. I say try to be inspired by previous design and take some elements into your own work. Don't be lazy and just copy. Take what you like and make it your own.

When designing a character that was created by someone else, do you like the description to be very detailed or open for interpretation?

Of course, I like it to be open for interpretation. But you have to feel out how "picky" your client is. For a new client, I always ask for as many specificities as possible. If I have worked with someone long enough, then I can feel them out and accordingly know how much leash they will give me and how much information I have to ask for.

If you had that golden nugget of information that you would pass on to other character designers, what would that be?

Stay modern, stay fresh, constantly be paying attention to what is going on around you. Character designs are very "in the moment"; stale designs equal no work.

Enrique Rivera

Concept Artist for games

Instagram: https://www.instagram.com/3nrique06

Character Design Questions

When initially coming up with a character, what is your process?

Story is king, unless you are designing for games, then *gameplay is king*. I like to have some sense of where the characters fit in the story. Their background, where they live, their personality, and the way they think. I need to get to know them as much as I can; thus, I explore a zillion ideas and refine that final design until the design itself speaks, the shapes flow, and the character is iconic enough that it can read at a distance. Similarly for games, but the focus there being the character's functionality.

If you start drawing first, when the story comes into play does your design change?

See answer 1.

How important is story to your design process?

See answer 1.

Do you pull certain attributes from iconic archetypes to help your designs?

That's tricky. It ultimately depends on the project and what you are trying to achieve. Archetypes are good shortcuts to convey much about a character when you have limited options. But at the same time, you run the risk of that character becoming generic, and that's okay if that's what the project calls for. The trick is to use those attributes to your advantage. Let's say you have a big, scruffy biker guy with a cigar. That's a pretty generic archetype. But hey, let's say you have a story with a big, scruffy turtle smoking a cigar. I'm using some of those generic attributes to create something new, but still familiar. That's the sweet spot in my opinion.

When designing characters, how important are the use of shapes and developing a strong silhouette?

Very important! And one should always be paying attention to this as you are designing. I like to keep a file with all the characters lined up, to make sure they read clearly, and have enough variety among the rest.

When designing characters, do you design in black and white and then go to color or work with color from the start?

That kind of varies per concept. Sometimes I have a clear vision of the character; other times there are certain parameters (i.e., all enemies are green) that have been established that one must follow. But more often than not, I spend a lot of time looking for a color scheme that tells me something about the character, and also highlights what elements of his design are the most important. I'm a big advocate of the 60/30/10 rule.

Should you cater to your audience when making characters or just design what you like?

I think it's important to keep them in mind. Since they are the ones buying your product. You want to pay attention to your demographic. The things you like in characters will slip in naturally because of the mere fact that you are drawing it.

Using reference is a hot topic when it comes to character design. What is your stance on using reference?

I wouldn't say it is a hot topic. There isn't much of a debate once you are in the industry. Reference is pretty much essential if you want to create things that are functional or believable. What you don't want to do is rely so much on the reference that you never

create anything original. You want to have a basic understanding of things so you can create something believable (i.e., How do certain metals reflect light? How does cloth fold? How do certain mechanisms work?). Not using reference is cool to exercise your imagination, and it's a good way to develop a new idea, but you need to fill your imagination with things first.

When designing a character that was created by someone else, do you like the description to be very detailed or open for interpretation?

That depends; both can be fulfilling in different ways. If it's very detailed, then it takes a lot of the guessing away, so you just do the task, but it also takes away from the creativity. If it's too open, you can do anything you want! But that often leads to becoming overwhelmed. The best ones have some restrictions (restrictions are your friend!), maybe a brief description, of the character's story, or their functionality. It becomes more like a puzzle that needs to be solved.

If you had that golden nugget of information that you would pass on to other character designers, what would that be?

Draw with emotion; make me feel something. Every character should emit some sort of emotion that we can connect with. Once we connect on an emotional level, then comes the cool superficial stuff!

Danny Araya

Storyboard Artist at Powerhouse Animation Studio

Twitter: @DannyAraya

Best known for in the art industry?

Storyboard and visual development for Netflix's *Castlevania* animated series

Character Design Questions

When initially coming up with a character, what is your process?

The first step for me is always to write down the character's personality traits and their role in the story relative to other characters. I find that if I skip this step, I tend to get caught up in the aesthetics of the design and I usually wind up with something that might be superficially interesting, but not specific enough to the story.

If you start drawing first, when the story comes into play does your design change?

Most of the time, yes. The only exception would be if parts of the production process have already started and it's too late to make any changes. It's not really a great sign for the production if this is happening.

How important is story to your design process?

It's crucial. Without knowing the character's role in the story, any artwork created tends to be a little meaningless. Sometimes elements of early designs can find their way into the final concept, but we tend to not have a lot of time for that sort of blue-sky ideation.

Do you pull certain attributes from iconic archetypes to help your designs?

Sometimes archetypes can be helpful to get across an idea quickly, especially when the story doesn't have much time for something more nuanced and specific. Generally, pulling from archetypes tends to work okay for tertiary characters, or sometimes it can be used as a jumping-off point if I'm feeling really stuck. There are also instances where clients will be adamant in sticking to archetypal design choices, and ultimately an artist's job is to give the client the best possible version of what they want.

When designing characters, how important are the use of shapes and developing a strong silhouette?

As a character designer, your entire job is to make sure your character design is clear, interesting, and relevant to the story and/or game design experience you're creating. Strong silhouette is probably the most effective way to deal with all three of those design challenges.

When designing characters, do you design in black and white and then go to color or work with color from the start?

I go straight in with color thumbnails. I use very simple, graphic blobs of color to try to get an overall sense of what the character's proportions and color profile will be as quickly as possible. When I have something I like, I toss it into a character lineup Photoshop document with the other characters in the project to make sure it fits the overall aesthetic but is distinct enough to be easily recognized at a glance.

Should you cater to your audience when making characters or just design what you like?

Both really. Your art director/director/client is ultimately going to be the audience you're designing for, but you should always try to make sure you're happy with what you're doing. I live in a perpetual state of uncertainty and second guessing, so when I get really excited

about a design, that's usually a good sign that it'll get a positive response. You have to trust your instincts, that's generally why you've been hired in the first place.

Using reference is a hot topic when it comes to character design. What is your stance on using reference?

Not using reference is idiotic and this debate needs to die. You need reference. Everyone needs reference.

When designing a character that was created by someone else, do you like the description to be very detailed or open for interpretation?

I prefer as much as detail as possible. Some artists are great at just blue-sky exploration and can churn out all kinds of art as they circle around a design. This is a totally valid way of working, but it's the complete opposite of me. I need as clear and specific a target as possible so that I can start making decisions based on the client's needs.

If you had that golden nugget of information that you would pass on to other character designers, what would that be?

What I said earlier about writing stuff down would probably be it. It's easy to get lost in the hundreds of things you need to consider when designing a character and you can get wrapped up in chasing the wrong idea. Write down your goals and draw your way toward them. Even when you fail, it'll be easier to figure out *why* you failed because you'll have a written list of criteria to check your work against. Trust the process and keep going.

Gallery

I want to congratulate you on getting to the end of this book. There was a lot of information to digest! Now that you have all the information you need to create sound character designs, I would like to show you some of the designs that were created in my studio.

I would like you to look at each design and compare it to the information you read in this book and see how well the designs followed the rules that were presented. Once again, congratulations on finishing the book, and I hope you learned something and enjoyed yourself at the same time.

AMPHION
DARK LEGACY

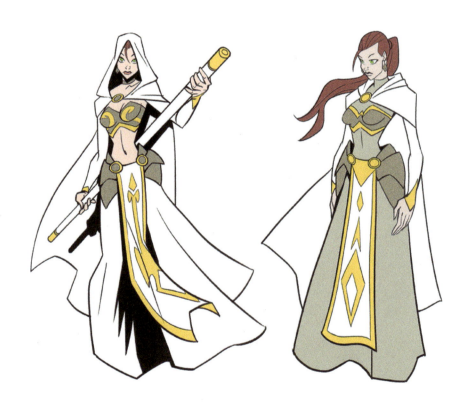

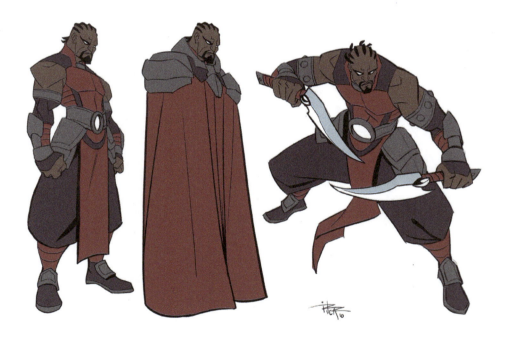

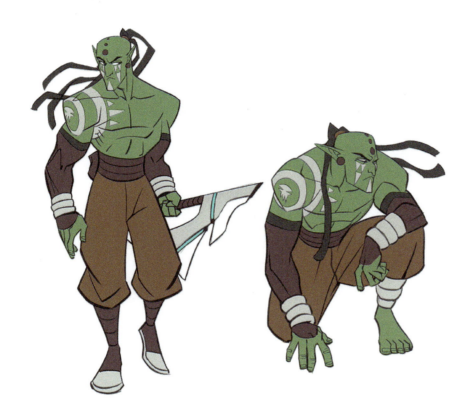

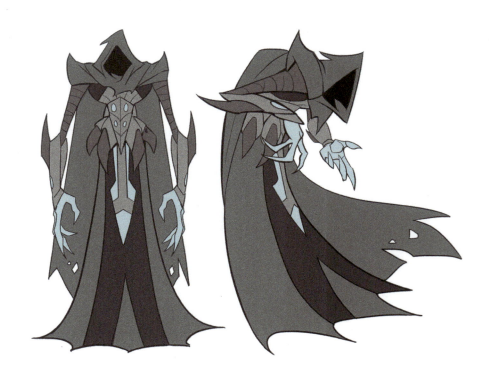

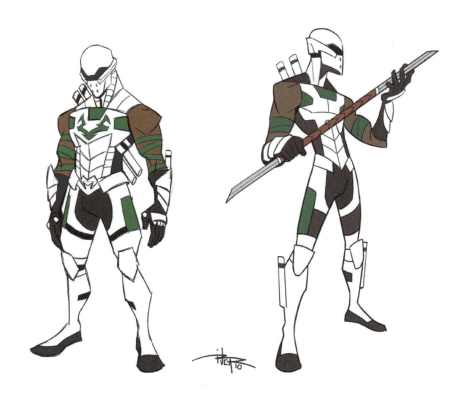

OLIVER

CRAVIN

JOCELYN

ZORZEL

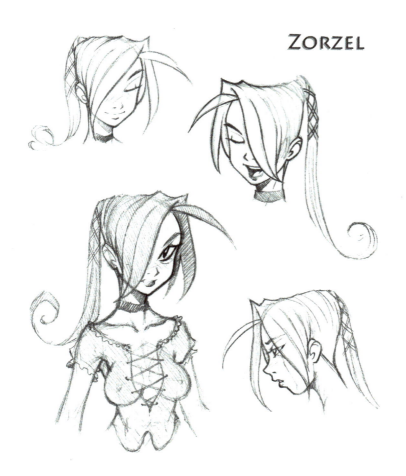

Mamon

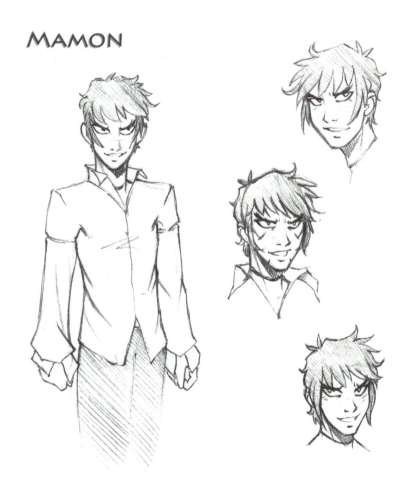

LUCIEL

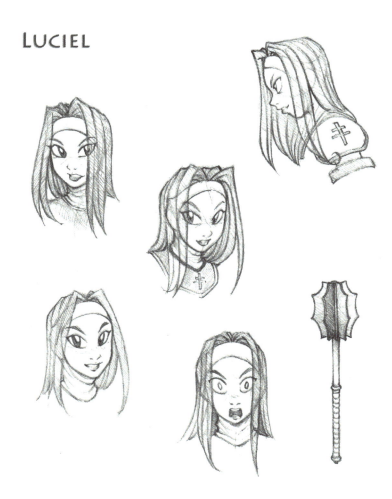

STAP D'LAMBS

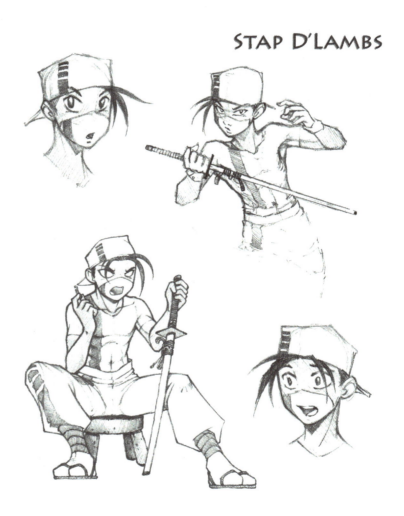

Lander

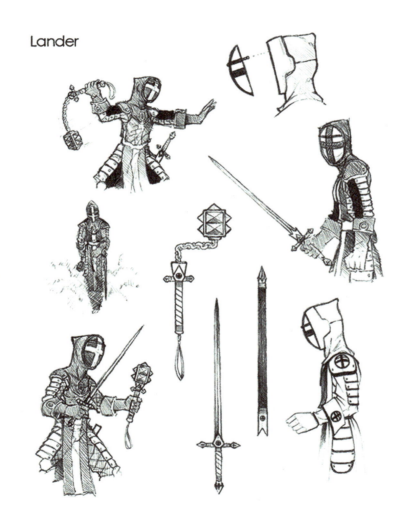

Vic Vertigo & Bethany Bedlam

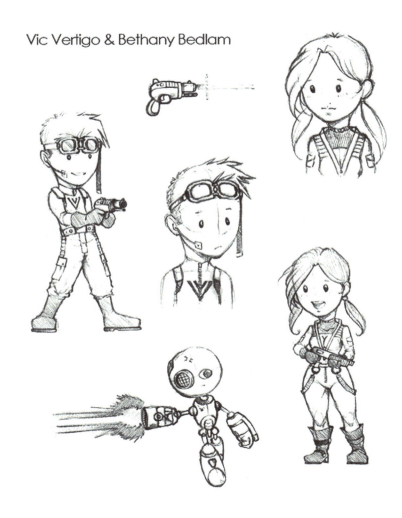

IR8

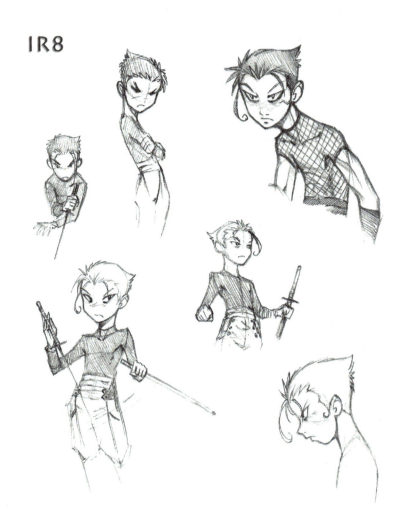

CHANH-CHANH

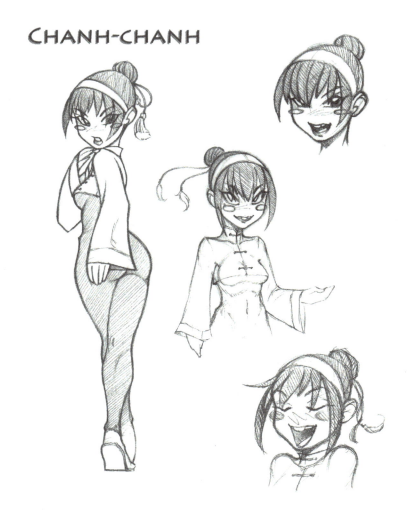

MELON PAN

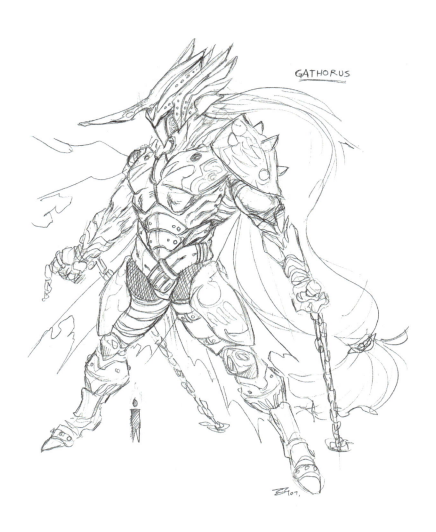

GATHORUS

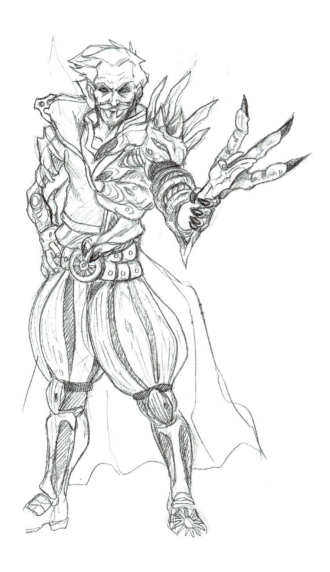

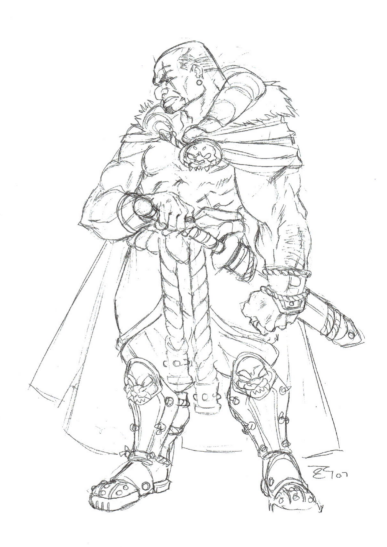

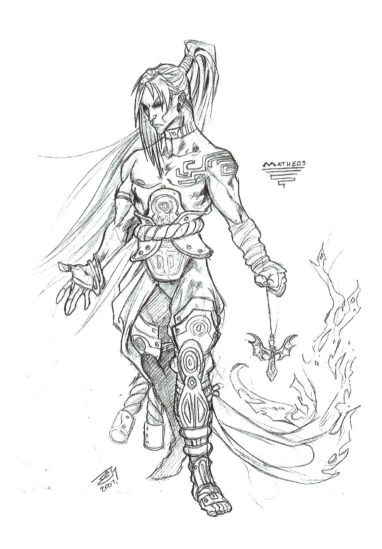

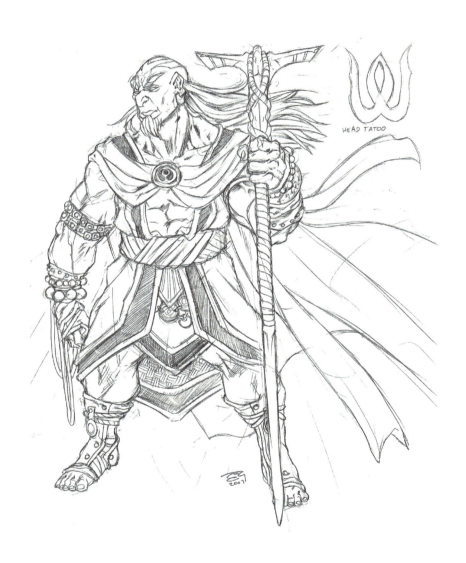

HEAD TATOO

KING
CERAS

NO
COAT

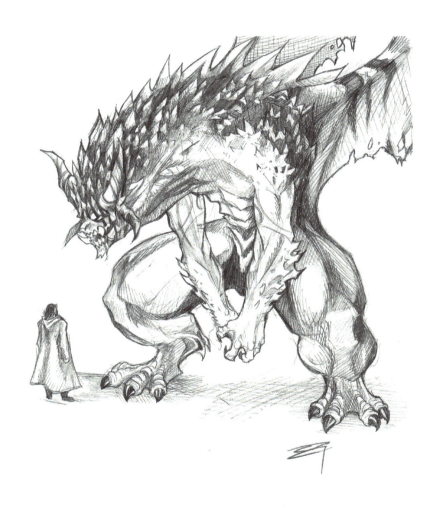

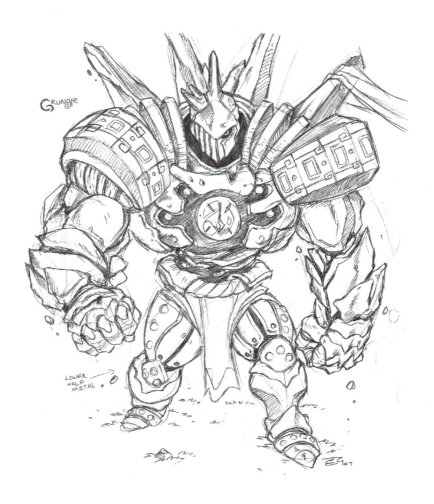

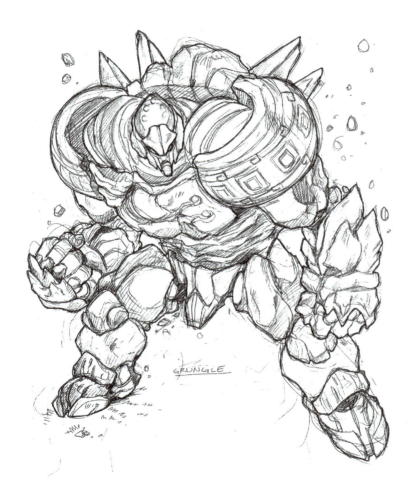

GRUNGLE

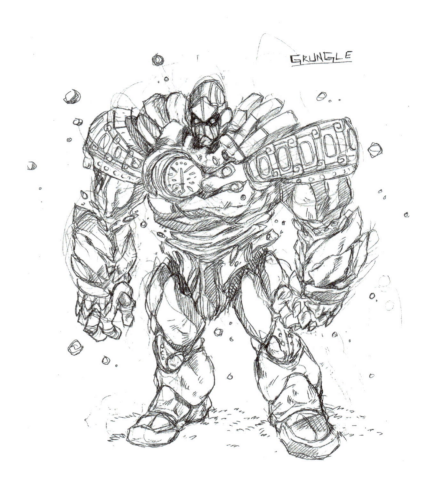

GRUNGLE

JIGOKU
HUMAN FORM

JIGO

http://www.posemaniacs.com
Pose Maniacs is a blog that tries to supports all artists, including art students and people who study illustrations and manga, by uploading a variety of poses for sketching. It also introduces other FLASH training tools for drawing.

http://www.marvel.com

http://www.dccomics.com
Some of the most influential character designs can be found at these two websites. They are a must for all character designers.

Character Design Template

Basic Statistics

Name:

Alias:

Age:

Height:

Weight:

Sex:

Race:

Eye Color:

Hair Color:

Glasses or Contact Lenses:

Nationality:

Skin Color:

Shape of Face:

Distinguishing Features:

Clothes: How does he/she dress?

Mannerisms:

Habits:

Health:

Hobbies:

Favorite Sayings:

Sound of Voice:

Walking Style:

Disabilities:

Character's Greatest Flaw:

Character's Best Quality:

Social Characteristics

Hometown:

Current Residence:

Occupation:

Income:

Talents/Skills:

Family Status:

Character Status as a Child:

Character Status as an Adult:

Attributes and Attitudes

Educational Background:

Intelligence Level:

Character's Goals in Life:

How does character see himself/herself?

How confident is the character?

Does the character seem ruled by emotion?

Emotional Characteristics

Introvert or Extrovert:

How does the character deal with:

- Sadness?
- Anger?
- Conflict?
- Change?
- Loss?

What would the character like to change about his/her life?

What motivates the character?

What frightens the character?

What makes this character happy?

Relationship Skills:

Spiritual Characteristics

Does the character believe in God?

How strong are the character's spiritual beliefs?

Is the character ruled by his/her spiritual beliefs?

Character's Involvement in the Story

What is the character's archetype?

How is the character affected by his/her environment?

Timeline

Time Period:

Describe five important background events that led up to the character's storyline.

Index